The Artist's Painting Library

LANDSCAPES IN OIL

BY WENDON BLAKE / PAINTINGS BY GEORGE CHEREPOV

WATSON-GUPTILL PUBLICATIONS/NEW YORK

First published 1979 in the United States and Canada by Watson-Guptill Publications,
a division of Billboard Publications, Inc.,
1515 Broadway, New York, N.Y. 10036

Library of Congress Cataloging in Publication Data
Blake, Wendon.
 Landscapes in oil.
 (His The artist's painting library)
 Originally published as pt. 2 of the author's The
oil painting book.
 1. Landscape painting—Technique. I. Cherepov,
George, 1909- II. Title. III. Series.
ND1342.B56 751.4'5 79-11963
ISBN 08230-2598-5

Manufactured in U.S.A.

First Printing, 1979

3 4 5 6 7 8 9/86 85 84 83

Landscapes in Oil. Whether you paint outdoors or indoors—or both—painting landscapes in oil is a great delight. Oil paint is amazingly versatile. If you enjoy working on location, you can pack all your tubes and brushes, your palette, plus a few canvas boards into a compact paintbox that's no bigger than a small valise. This box becomes a kind of traveling studio. Flip open the lid—which stands up to function as your easel—and you're ready to paint anywhere. If you're a quick and impulsive painter, you can work with decisive strokes and finish a landscape in a few hours, right on the spot. If you prefer to work more slowly and deliberately, you can start a painting on the spot and finish the picture at home; because oil paint takes several days to dry, the colors on the canvas remain soft and pliable, giving you plenty of time to complete the landscape at your leisure. Or if you'd rather start *and* finish a painting in the comfort of home, you can always make some quick oil sketches on location and then take these indoors to use as reference material for a larger, more ambitious painting. Oil paint will always adapt itself to your personality and your working habits.

Indoors or Outdoors. Although some people are outdoor painters and others are indoor painters, it's important to remember that the best landscape paintings always *start* outdoors, even if they're finished in the studio. The only way to learn how to paint a tree or a rock is to set up your paintbox right there in the meadow. There's no substitute for firsthand knowledge of your subject. Working on location will strengthen your powers of observation and train your visual memory. So it's important to spend as much time as you can painting on location, even if those paintings are nothing more than small, quick studies for larger paintings which you hope to develop indoors. Those outdoor paintings—no matter how rough and crude they may turn out to be—will have a freshness and authenticity that you can get only by looking straight at the subject. Then, if you want to use these outdoor paintings as the basis for more work indoors, your indoor paintings will have a feeling of reality that you can never get by painting from memory—or from a photograph.

Basic Techniques. *Landscapes in Oil* begins with a rapid review of some fundamental techniques. First, you'll see how to use bristle brushes for a roughly textured subject such as the rugged forms of a cliff and rocks. Then you'll see how to combine stiff bristle brushes with more pliable softhair brushes to paint a subject—such as trees and grass—that combines rough brushwork with softer strokes. The Italian word *impasto* means thick paint and you'll see how the im-

pasto technique is used to paint a mountainous landscape. When you paint in oils, it's usually a good idea to start out with thin color and gradually work your way toward thicker color: you'll see how this is done in a snowy landscape.

Color Sketches. Several pages of color sketches will give you some guidelines for painting the various colors of trees, skies, land, and water. You'll compare the very different greens of deciduous trees and evergreens, the hot colors of autumn and the more delicate colors of trees on an overcast day. You'll see how the color of the sky changes from a sunny day to a gray day. You may be surprised to discover how many different greens you can find in a landscape of meadows and hills, or how many different tones you can see in a sandy shore. And you'll see how the colors of water change as they reflect the surrounding landscape and the sky.

Painting Demonstrations. After looking at some close-ups of sections of various landscapes—which will show you various ways of handling color—you'll watch noted painter George Cherepov demonstrate, step-by-step, how to paint ten of the most popular landscape subjects. He begins with trees and other growing things: deciduous trees, a forest of evergreens, and a meadow with trees and wildflowers. Then he goes on to the big shapes of the landscape: hills and mountains. He shows you how to paint two different kinds of skies: a sunny sky filled with puffy clouds, and the dramatic shapes and colors of a sunset. He concludes with three different forms of water: a stream with a rocky shore, a winter landscape with snow and ice, and a pond filled with the reflections of trees. Each step of these demonstrations is shown in color.

Special Problems. Following these painting demonstrations, you'll find guidance on selecting landscape subjects and you'll find some rules of thumb for composing effective landscapes. You'll learn how the direction of the light can radically change the look of trees or mountains—or any other subject. You'll see how linear and aerial perspective can enhance the sense of space in your landscape paintings. Demonstration paintings of a gnarled tree and a hilly landscape will show how your brushstrokes can create a feeling of texture or three-dimensional form. You'll observe how expressive brushwork can emphasize the unique character of the subject, whether it's a cloud formation or a forest. And the book concludes with suggestions about painting the diverse forms of trees, certainly one of the most common landscape elements throughout the world.

CONTENTS

Color Selection. When you walk into an art supply store, you'll probably be dazzled by the number of different colors you can buy. There are far more tube colors than any artist can use. In reality, all the paintings in this book were done with just a dozen colors, about the average number used by most professionals. The colors listed below are really enough for a lifetime of painting. You'll notice that most colors are in pairs: two blues, two reds, two yellows, two browns. One member of each pair is bright, the other is subdued, giving you the greatest possible range of color mixtures.

Blues. Ultramarine blue is a dark, subdued hue with a faint hint of violet. Phthalocyanine blue is much more brilliant and has surprising tinting strength—which means that just a little goes a long way when you mix it with another color. So add phthalocyanine blue very gradually. These two blues will do almost every job. But George Cherepov likes to keep a tube of cobalt blue handy for painting skies and flesh tones; this is a beautiful, very delicate blue, which you can consider an "optional" color.

Reds. Cadmium red light is a fiery red with a hint of orange. All cadmium colors have tremendous tinting strength, so remember to add them to mixtures just a bit at a time. Alizarin crimson is a darker red and has a slightly violet cast.

Yellows. Cadmium yellow light is a dazzling, sunny yellow with tremendous tinting strength, like all the cadmiums. Yellow ochre is a soft, tannish tone. If your art supply store carries two shades of yellow ochre, buy the lighter one.

Browns. Burnt umber is a dark, somber brown. Burnt sienna is a coppery brown with a suggestion of orange.

Green. Although nature is full of greens—and so is your art supply store—you can mix an extraordinary variety of greens with the colors on your palette. But it *is* convenient to have just one green available in a tube. The most useful green is a bright, clear hue called viridian.

Black and White. The standard black, used by almost every oil painter, is ivory black. Buy either zinc white or titanium white; there's very little difference between them except for their chemical content. Be sure to buy the biggest tube of white sold in the store; you'll use lots of it.

Linseed Oil. Although the color in the tubes already contains linseed oil, the manufacturer adds only enough oil to produce a thick paste that you squeeze out in little mounds around the edge of your palette. When you start to paint, you'll probably prefer more fluid color. So buy a bottle of linseed oil and pour some into that little metal cup (or "dipper") clipped to the edge of your palette. You can then dip your brush into the oil, pick up some paint on the tip of the brush, and blend oil and paint together on your palette to produce the consistency you want.

Turpentine. Buy a big bottle of turpentine for two purposes. You'll want to fill that second metal cup, clipped to the edge of your palette, so that you can add a few drops of turpentine to the mixture of paint and linseed oil. This will make the paint even more fluid. The more turpentine you add, the more liquid the paint will become. Some oil painters like to premix linseed oil and turpentine, 50-50, in a bottle to make a thinner *painting medium*, as it's called. They keep the medium in one palette cup and pure turpentine in the other. For cleaning your brushes as you paint, pour some more turpentine into a jar about the size of your hand and keep this jar near the palette. Then, when you want to rinse out the color on your brush and pick up a fresh color, you simply swirl the brush around in the turpentine and wipe the bristles on a newspaper.

Painting Mediums. The simplest painting medium is the traditional 50-50 blend of linseed oil and turpentine. Many painters are satisfied to thin their paint with that medium for the rest of their lives. On the other hand, art supply stores do sell other mediums that you might like to try. Three of the most popular are damar, copal, and mastic painting mediums. These are usually a blend of a natural resin—called damar, copal, or mastic, as you might expect—plus some linseed oil and some turpentine. The resin is really a kind of varnish that adds luminosity to the paint and makes it dry more quickly. Once you've tried the traditional linseed oil-turpentine combination, you might like to experiment with one of the resinous mediums.

Other Solvents. If you can't get turpentine, you'll find that mineral spirits (the British call it white spirit) is a good alternative. You can use it to thin your colors and also to rinse your brushes as you work. Some painters use kerosene (called paraffin in Britain) for cleaning their brushes, but it's flammable and has a foul odor. Avoid it.

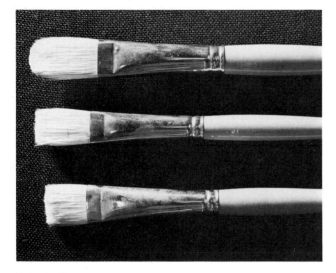

Bristle Brushes. The brushes most commonly used for oil painting are made of stiff, white hog bristles. The filbert (top) is long and springy, comes to a slightly rounded tip, and makes a soft stroke. The flat (center) is also long and springy, but it has a squarish tip and makes a more precise, rectangular stroke. The bright (bottom) also has a squarish tip and makes a rectangular stroke, but it's short and stiff, digging deeper into the paint and leaving a strongly textured stroke.

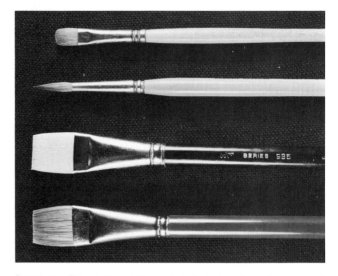

Softhair Brushes. Although bristle brushes do most of the work in oil painting, it's helpful to have some softhair brushes for smoother, more precise brushwork. The top two brushes here are sables: a small, flat brush that makes smooth, rectangular strokes; and a round, pointed brush that makes fluent lines for sketching in the picture and adding linear details such as leaves, branches, or eyebrows. At the bottom is an oxhair brush, and just above it is a soft, white nylon brush; both make broad, smooth, squarish strokes.

Knives. A palette knife (top) is useful for mixing color on the palette, for scraping color off the palette at the end of a painting session, and for scraping color off the canvas when you're dissatisfied with what you've done and want to make a fresh start. A painting knife (bottom) has a very thin, flexible blade that's specially designed for spreading color on the canvas.

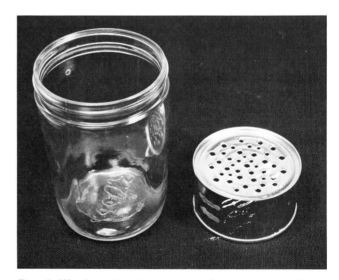

Brush Washer. To clean your brush as you paint, rinse it in turpentine or mineral spirits (called white spirit in Britain). To create a convenient brush washer, save an empty food tin after you've removed the top; turn the tin over so that the bottom faces up; then punch holes in the bottom with a pointed metal tool. Drop the tin into a wide-mouthed jar—with the perforated bottom of the tin facing up. Fill the jar with solvent. When you rinse your brush, the discarded paint sinks through the holes to the bottom of the jar, the solvent above the tin remains fairly clean.

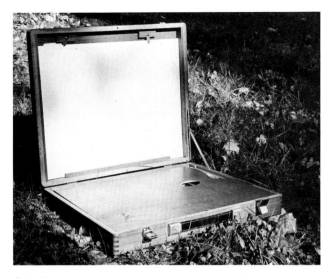

Easel. For working indoors, a wooden studio easel is convenient. Your canvas board, stretched canvas, or gesso panel is held upright by wooden "grippers" that slide up and down to fit the size of the painting. They also adjust to match your own height. A studio easel should be the heaviest and sturdiest you can afford, so that it won't wobble when you attack the painting with vigorous strokes. For working outdoors, you can get a lightweight, collapsible, tripod easel; to keep it steady in the wind, some professionals sharpen the three legs and drive them into the ground.

Paintbox. A paintbox usually contains a wooden palette that you can lift out and hold as you paint. Beneath the palette, the lower half of the box contains compartments for tubes, brushes, knives, bottles of oil and turpentine, and other accessories. The lid of the paintbox often has grooves into which you can slide two or three canvas boards. The open lid will stand upright—with the help of a supporting metal strip which you see at the right—and can serve as an easel when you paint outdoors.

Palette. The wooden palette that comes inside your paintbox is the traditional mixing surface that artists have used for centuries. A convenient alternative is the paper tear-off palette: sheets of oilproof paper that are bound together like a sketchpad. You mix your colors on the top sheet, which you then tear off and discard at the end of the painting day, leaving a fresh sheet for the next painting session. This takes a lot less time than cleaning a wooden palette. Many artists also find it easier to mix colors on the white surface of the paper palette than on the brown surface of the wooden palette.

Palette Cups. These two metal cups (or dippers) have gripping devices along the bottom so that you can clamp the cups over the edges of your palette. One cup is for turpentine or mineral spirits to thin your paint as you work. (Don't use this cup for rinsing your brush; that's what the brush washer is for.) The other cup is for your painting medium. This can be pure linseed oil; a 50-50 blend of linseed oil and turpentine that you mix yourself; or a painting medium that you buy in the art supply store—usually a blend of linseed oil, turpentine, and a resin such as damar, copal, or mastic.

Cliff and Rocks. The stiff, white hoghairs of a bristle brush are best for broad, rough strokes, which usually show the marks of the bristles. If you use the paint straight from the tube—adding little or no painting medium—the color has a thick, pasty consistency. A stiff bristle brush, loaded with stiff color, is particularly effective for painting roughly textured subjects such as a rock formation. If you add a little painting medium to make the tube color more fluid, the paint becomes creamier and you can make softer strokes like those in the sky at the upper right. Oil painters generally do most of their work with bristle brushes, covering the canvas with big, broad strokes.

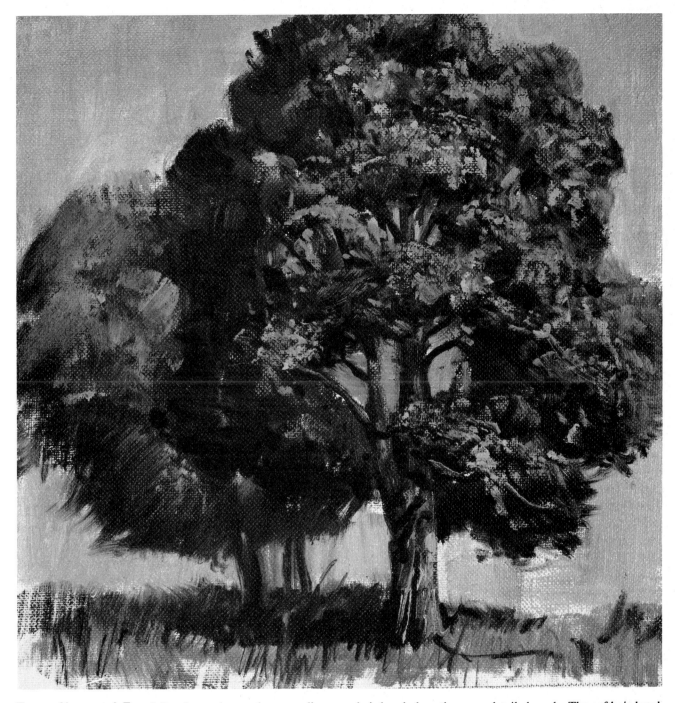

Trees, Near and Far. Like the rocks on the preceding page, these trees are begun with broad strokes of a bristle brush. However, the paint is diluted with medium to a more fluid consistency, so that the brush makes a softer, smoother stroke, which you can see most clearly in the shadow side of the foreground tree. The hoghairs still leave a distinct mark in the paint, but the stroke isn't nearly as rough. On top of the big strokes of the bristle brush, the tip of a round, soft-hair brush does the more detailed work. The softhair brush adds the paler touches of the leaves in sunlight, the linear strokes of the branches, the vertical shadow strokes on the sunlit treetrunk, and the scribbly strokes of the grass beneath the trees. The slender, delicate hairs of the softhair brush won't carry as much thick paint as the bristle brush. Softhair brushes work best with fluid paint, so add plenty of medium.

Step 1. The shapes of the cliffs and rocks are drawn with straight strokes of a small filbert carrying paint that's diluted with turpentine to a very fluid consistency. Undiluted tube color is too thick for drawing lines, so you've got to add turpentine or medium.

Step 2. A larger bristle brush picks up some slightly thicker color diluted with just enough medium to make the paint flow smoothly. Then the dark shadow sides of the cliff and rocks are painted with broad strokes. Notice how the texture of the canvas board breaks up the strokes, which begin to suggest the roughness of the rocks.

Step 3. Now the sunlit faces of the boulders and the cliff are painted with undiluted tube color. This stiff paint is applied with the short, stiff bristles of a bright, which makes a stroke that has a particularly rough texture. The paint is so thick that it doesn't cover the canvas in smooth, even strokes. You can see that the strokes are ragged and irregular. On the face of the big rock at the center, the weave of the canvas breaks up the stroke to accentuate the rocky texture.

Step 4. For the softer, more fluid strokes of the sky, a large filbert picks up much creamier paint, diluted with medium to a more fluid consistency than the rocks. You can still see the brushstrokes, but they're softer and less distinct. For details such as the dark cracks, the point of a round, softhair brush adds a few dark strokes of very fluid color containing plenty of medium. Finally, a bright adds some thick strokes of undiluted color to strengthen the sunlit tops of the rocks.

Step 1. For drawing the complex curves of the foliage and the delicate shapes of the trunks and branches of these trees, a round, softhair brush will do a more precise job than a bristle brush. The color is thinned with turpentine to the consistency of watercolor. Then the tip of the brush moves smoothly over the surface of the canvas, making crisp, graceful lines.

Step 2. To block in the darks of the foliage, a large filbert picks up a fluid mixture of tube color and painting medium. The bristle brush scrubs in the tones with broad strokes that retain the marks of the stiff hoghairs and suggest the texture of the foliage. Notice the small, rough strokes which really begin to look like leaves at the top of the tree.

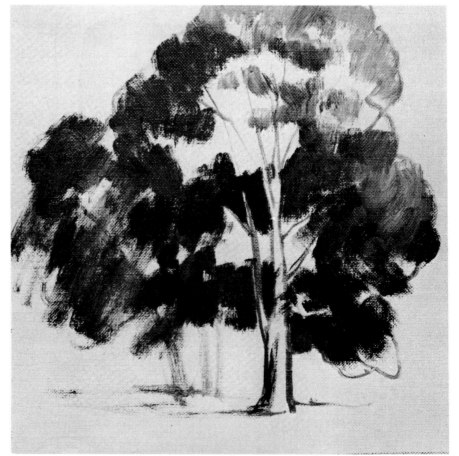

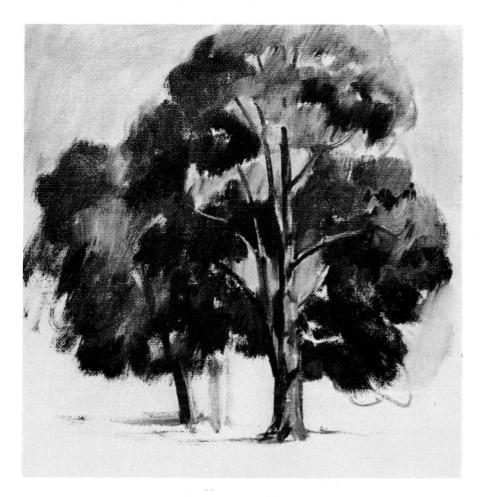

Step 3. the filbert completes the large shapes of the foliage with broad strokes of fluid color containing a lot of painting medium. Then the tip of a round, softhair brush adds precise, linear strokes for the sunlit and shadow sides of the trunk and branches. The shadow strokes are precisely drawn with fluid color containing enough medium to make the paint flow smoothly.

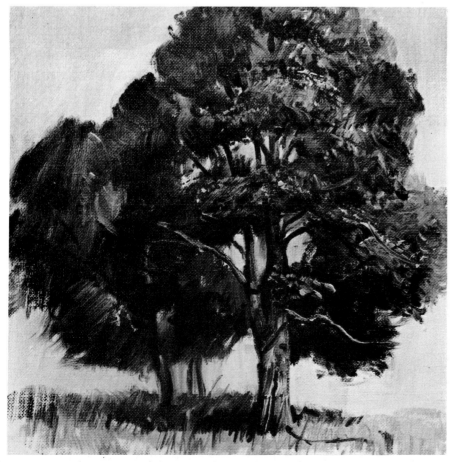

Step 4. A flat, softhair brush picks up fluid color to complete the distant tree with soft, smooth strokes that blend the lights and darks and soften the edges of the leafy masses. Then the tip of a round, softhair brush picks up a slightly thicker mixture of tube color and painting medium to dash in the sunlit leaves with small, quick strokes. The same brush paints the sunlit sides of the trunks and branches with long, slender strokes of this creamy mixture. Then, picking up more fluid color, a round brush scribbles the shadowy grass at the bases of the trees.

Step 1. This picture will be completed with thick color—for which painters use the Italian word *impasto*—but the shapes are first drawn with precise strokes of fluid color. The tip of a round softhair brush defines the mountains and the trees with tube color thinned with turpentine to the consistency of watercolor.

Step 2. Now the dark shapes of the distant mountains at the horizon are painted with a creamy mixture of tube color and painting medium. The shadowy patch of snow is painted with slightly thicker color—tube color and a little less painting medium. At this stage, all the work is done with bristle brushes.

Step 3. The shadowy patches of snow in the foreground are painted with a bristle brush that carries color diluted to the consistency of thick cream. The *really* thick color is saved for the sunlit patches of snow, which are pure tube color undiluted with painting medium and applied in solid, heavy strokes. A round softhair brush adds small, dark touches such as the trees.

Step 4. To add some strokes of shadow to the sunlit snow, a bristle brush digs back into the thick, wet color applied in Step 3. Then the foreground is completed with strokes made by a round, softhair brush. The strategy of this painting is worth remembering. The most distant shapes are painted with smooth, fairly thin color. The thick color is saved for the sunlit foreground.

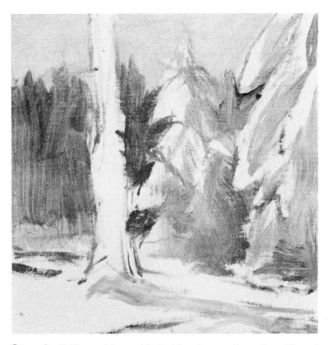

Step 1. Most oil painters make it a standard practice to begin with thin color—diluted with lots of turpentine or painting medium—and gradually introduce thicker color as the painting progresses. This snowy landscape begins with a brush drawing in very thin color diluted with turpentine. The preliminary shapes are drawn with the tip of a round softhair brush.

Step 2. Still working with fluid paint—tube color diluted with painting medium and a little turpentine—a bristle brush adds the shadow tones on the snow-covered trees, plus the dark shape of the trees in the distance. A pale tone is also brushed across the sky, while a strip of shadow is brushed across the foreground.

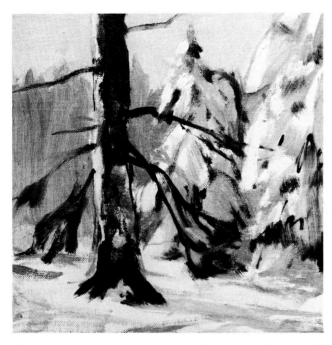

Step 3. Working with slightly thicker color diluted with medium to the consistency of thick cream, a bristle brush paints the sunlit patches on the snow-covered trees and the foreground. Then a round, softhair brush begins to add the darks with strokes of fluid color a little thicker than the color used in Step 2, but not as thick as the sunlit snow.

Step 4. Following the same strategy that was used for painting the mountains, the thickest strokes are saved for the very end. Now the paint is really piled on with a bristle brush to solidify the shapes of the snow on the trees and on the ground. And a round, softhair brush adds creamy strokes to suggest snow on the branches of the dark tree.

Buying Brushes. There are three rules for buying brushes. First, buy the best you can afford—even if you can afford only a few. Second, buy big brushes, not little ones; big brushes encourage you to work in bold storkes. Third, buy brushes in pairs, roughly the same size. For example, if you're painting a sky, you can probably use one big brush for the patches of blue and the gray shadows on the clouds, but you'll want another brush, unsullied by blue or gray, to paint the white areas of the clouds.

Recommended Brushes. Begin with a couple of really big bristle brushes, around 1″ (25 mm) wide for painting your largest color areas. You might want to try two different shapes: one can be a flat, while the other might be a filbert. And one might be just a bit smaller than the other. The numbering system of manufacturers vary, but you'll probably come reasonably close if you buy a number 12 and a number 11. Then you'll need two or three bristle brushes about half this size, numbers 7 and 8 in the catalogs of most brush manufacturers. Again, try a flat, a filbert, and perhaps a bright. For painting smoother passages, details, and lines, three softhair brushes are useful: one that's about 1/2″ (13 mm) wide; one that's about half this wide; and a pointed, round brush that's about 1/8″ or 3/16″ (3-5 mm) thick at the widest point.

Knives. For mixing colors on the palette and for scraping a wet canvas when you want to make a correction, a palette knife is essential. Many oil painters prefer to mix colors with the knife. If you'd like to *paint* with a knife, don't use the palette knife. Instead, buy a painting knife, with a short, flexible, diamond-shaped blade.

Painting Surfaces. When you're starting to paint in oil, you can buy inexpensive canvas boards at any art supply store. These are canvas coated with white paint and glued to sturdy cardboard in standard sizes that will fit into your paintbox. Later, you can buy stretched canvas—sheets of canvas, precoated with white paint and nailed to a rectangular frame made of wooden stretcher bars. You can save money by stretching your own canvas. You buy the stretcher bars and canvas, then assemble them yourself. If you like to paint on a smooth surface, buy sheets of hardboard and coat them with acrylic gesso, a thick, white paint that you buy in cans or jars, then thin with water.

Easel. An easel is helpful, but not essential. It's just a wooden framework with two "grippers" that hold the canvas upright while you paint. The "grippers" slide up and down to fit larger or smaller paintings—and to match your height. If you'd rather not invest in an easel, there's nothing wrong with hammering a few nails partway into the wall and resting your painting on them; if the heads of the nails overlap the edges of the painting, they'll hold it securely. Most paintboxes have lids with grooves to hold canvas boards. When you flip the lid upright, the lid becomes your easel.

Paintbox. To store your painting equipment and to carry your gear outdoors, a wooden paintbox is a great convenience. The box has compartments for brushes, knives, tubes, small bottles of oil and turpentine, and other accessories. It usually holds a palette—plus some canvas boards inside the lid.

Palette. A wooden paintbox often comes with a wooden palette. Rub the palette with several coats of linseed oil to make the surface smooth, shiny, and nonabsorbent. When the oil is dry, the palette won't soak up your tube colors and the surface will be easy to clean at the end of the painting day. Even more convenient is a paper palette. This looks like a sketchpad, but the pages are nonabsorbent paper. At the beginning of the painting day, you squeeze out your colors on the top sheet. When you're finished, you just tear off and discard the top sheet. Paper palettes come in standard sizes that fit into paintboxes.

Odds and Ends. To hold your turpentine and your painting medium—which might be plain linseed oil or one of the mixtures you read about earlier—buy two metal palette cups (or "dippers"). To sketch the composition on your canvas before you start to paint, buy a few sticks of natural charcoal—not charcoal pencils or compressed charcoal. Keep a clean rag handy to dust off the charcoal and make the lines paler before you start to paint. Some smooth, absorbent, lint-free rags are good for wiping mistakes off your painting surface. Paper towels or a stack of old newspapers (a lot cheaper than paper towels) are essential for wiping your brush when you've rinsed it in turpentine. For stretching your own canvas, buy a hammer (preferably with a magnetic head), some nails or carpet tacks about 3/8″ (9-10 mm) long, scissors, and a ruler.

Work Layout. Before you start to paint, lay out your equipment in a consistent way, so that everything is always in its place when you reach for it. If you're right-handed, place the palette on a tabletop to your right, along with a jar of turpentine, your rags and newspapers or paper towels, and a clean jar in which you store your brushes, hair end up. Establish a fixed location for each color on your palette. One good way is to place your *cool* colors (black, blue, green) along one edge and the *warm* colors (yellow, orange, red, brown) along another edge. Put a big dab of white in one corner, where it won't be contaminated.

Deciduous Trees. To paint trees in bright sunlight, try mixing phthalocyanine blue of viridian with cadmium yellow to get brilliant greens, or ultramarine blue with cadmium yellow for greens which are slightly more subdued but still sunny. Here, the sunstruck foliage and grass are ultramarine blue, cadmium yellow, and a little white; the shadow areas are ultramarine blue and yellow ochre.

Evergreens. Pines, spruces, and other evergreens tend to be deeper shades of green than deciduous trees. To darken a mixture of phthalocyanine blue or ultramarine blue and cadmium yellow, add burnt umber, burnt sienna, or ivory black. Phthalocyanine blue and yellow ochre will give you particularly deep green, which grows smoky and mysterious when you add some white—perfect for distant evergreens or evergreens in mist.

Autumn Trees. The hot colors of autumn call for brilliant colors such as cadmium yellow or cadmium red, but it's best to subdue them slightly with more muted colors such as yellow ochre, burnt umber, and burnt sienna. The yellow tree is cadmium yellow, burnt sienna, and white. The orange tone in the background is cadmium yellow, cadmium red, yellow ochre, and white.

Trees on Overcast Day. On a gray day, even the bright colors of autumn are subdued. The warm tones of the foreground tree and the grass are mixtures of viridian, yellow ochre, burnt sienna, and white. The distant trees, melting away into the atmosphere, are mixtures of ultramarine blue, burnt sienna, yellow ochre, and white.

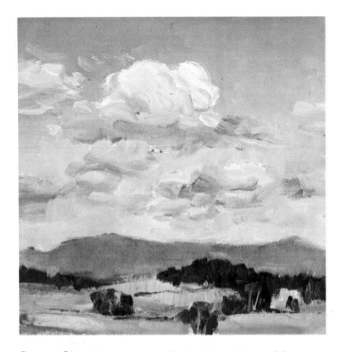

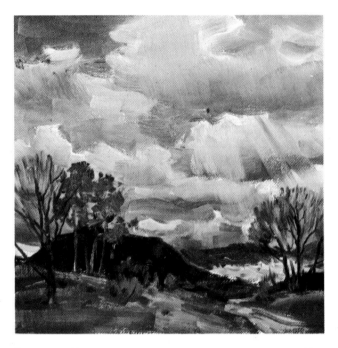

Sunny Sky. The sky is usually darkest at the zenith, growing paler at the horizon. Don't just mix blue and white. Try adding a touch of yellow ochre or alizarin crimson for warmth, or perhaps viridian to make the blue cooler and brighter. This sky is mainly cobalt blue and white, with a slight hint of yellow ochre and alizarin crimson. The clouds are also this mixture, but with less blue.

Overcast Day. An overcast sky is full of subtle color. Try mixing one of your blues (ultramarine, phthalocyanine, or cobalt) with one of your browns (burnt umber or burnt sienna) and plenty of white to produce a great variety of beautiful warm and cool grays. Add a touch of yellow ochre for a more golden tone. This cloudy sky is painted with mixtures of cobalt blue, burnt sienna, yellow ochre, and white.

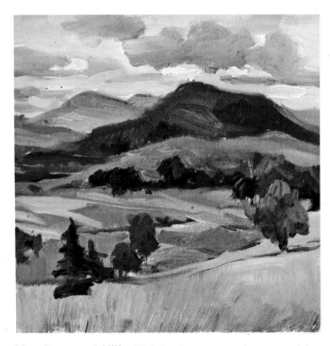

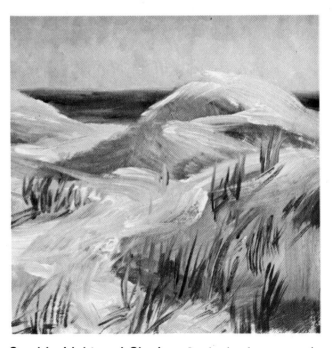

Meadows and Hills. This landscape contains a surprising variety of green mixtures: various combinations of ultramarine blue or viridian, cadmium yellow or yellow ochre, burnt sienna, and white for the lighter areas; various blends of phthalocyanine blue, cadmium yellow or yellow ochre, and burnt umber for the darks. For contrast, it's a good idea to exaggerate the blueness of the distant hills.

Sand in Light and Shadow. Look closely at a sandy beach and you'll see that it isn't nearly as yellow or gold as most beginners paint it. The sunlit areas of these dunes are mostly yellow ochre and white, heightened with delicate touches of cadmium yellow and burnt sienna. The shadows tend to reflect the cool tone of the sky—mixtures of cobalt blue, yellow ochre, alizarin crimson, and white.

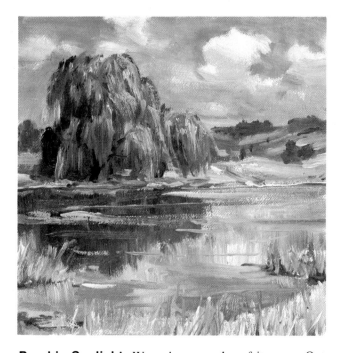

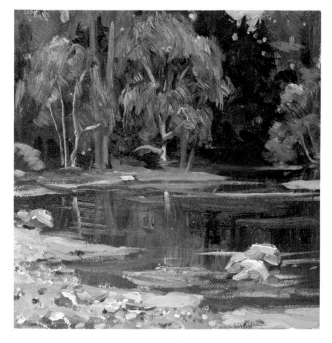

Pond in Sunlight. Water has no color of its own. Outdoors, the water acts like a mirror, reflecting the color of the surrounding sky and landscape. That's why most of this pond is painted with the same colors as the sky: cobalt blue, yellow ochre, alizarin crimson, and white. For the same reason, the water below the big willow is painted with the same mixtures used to render the tree.

Pond in Deep Woods. Surrounded by dark woods, a pond reflects very little sky color. Instead, the water picks up the colors of the surrounding trees. At the very top, a few patches of sky break through the trees, and these sky colors are reflected in a few streaks and ripples that break the water.

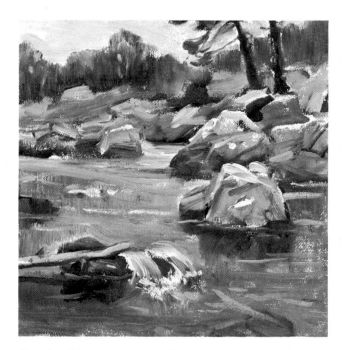

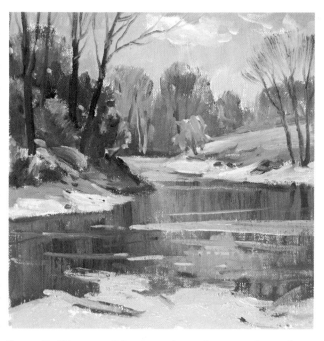

Rocky Stream. A turbulent stream is a particularly complicated combination of colors. Much of this stream reflects the tones of the surrounding rocks. You can see some cooler strokes that reflect the cooler tone of the sky—although the blue zenith of the sky is too far up to include in the picture. In the immediate foreground, the shallow water reveals the darker tone of the bed of the stream.

Smooth Stream. Calm water is an almost perfect reflecting surface. Look carefully at this placid stream, and you'll see reflections of the trunks and foliage along the shore, plus a clearly defined patch of sky color in the lower right area. The lesson is clear: don't try to mix some imaginary "water color," but paint water as a reflecting surface that mirrors its surroundings.

Warm Picture with Cool Notes. Painters often talk about "warm and cool colors." Reds, oranges, yellows, and browns are in the warm family. Blues and greens are generally regarded as cool colors. Some colors can go either way: a blue-green is considered cool, while a yellow-green is warm; a purple that tends toward blue would be considered cool, while a red-purple is warm. Grays are particularly interesting because it's possible to mix so many different warm and cool tones: a bluish or greenish gray would be considered cool, while a gray that tends toward brown or gold would certainly be warm. When you paint a landscape, think about the *balance* of warm and cool colors. This is a predominantly warm landscape—mostly yellows, yellow-greens, browns, and brownish grays. But the overall warmth is relieved here and there by touches of cooler gray on the treetrunks and the path. And notice those small strokes of cool color on the bush at the center.

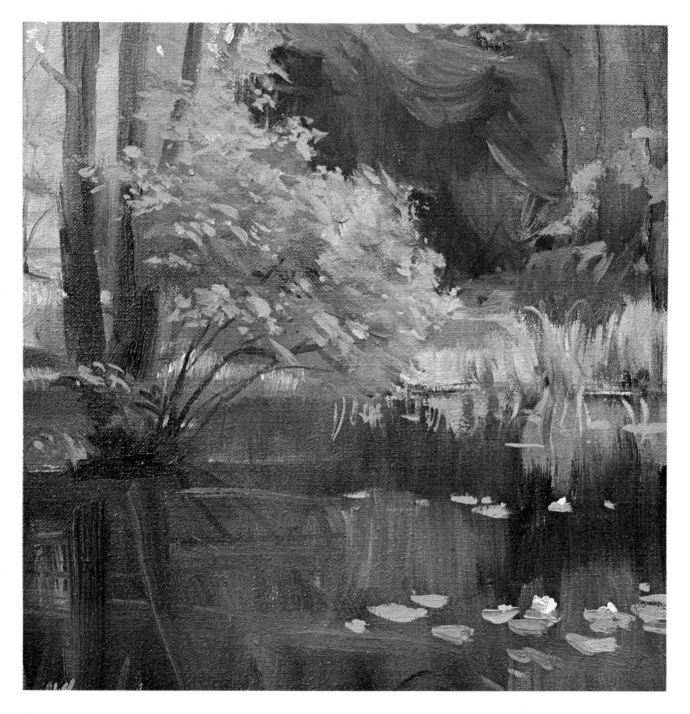

Cool Picture with Warm Notes. This is a close-up of a section of a woodland landscape that's painted almost entirely in cool colors. At first glance, the painting seems to consist entirely of greens. But look closely and you'll see many warm notes that lend variety and vitality to the green color scheme—which would be terribly monotonous without these subtle notes of contrast. There are many subtle touches of yellow and yellow-green among the foliage; these tones are brushed into the deep green of the water. The lily pads floating on the pond aren't a uniform green, but contain touches of yellow. At the left, the treetrunks are also a distinctly warm tone. It isn't always easy to find warm notes in a cool landscape or cool notes in a warm landscape—so *exaggerate* the contrasting colors that you do find. Or *invent* them if necessary.

Color Creates Space. When you're painting landscapes, it's important to create a convincing sense of space—a feeling that some parts of the picture are close to the viewer, while other parts are further away. Color can help. In this close-up of a section of a wooded landscape, the darkest and the brightest colors are in the foreground. The deepest tones appear in the big tree, while the brightest colors appear in the clusters of leaves. The forest beyond seems further away because the colors are paler and more subdued. This phenomenon is called *aerial perspective*. According to the "rules" of aerial perspective, near objects tend to be darker or brighter than more distant objects—which tend to be paler and more muted in color. Professional landscape painters often exaggerate these color differences to make their pictures look more spacious.

Value Creates Space. Painters often talk about the *value* of a color—which means its relative lightness or darkness. To create a convincing sense of space in a landscape, it's important to plan your values carefully. In this close-up of a portion of a winter landscape, the values clearly define the foreground, middleground, and distance. The trees and the slope in the foreground are one distinct tone, with some strong darks to make the trees move forward toward the viewer. Just beyond the shadowy trees is a field of sunlit snow with a stand of evergreens at the edge of the field. The snow is lighter and the evergreens are darker than the foreground; together they constitute the middleground of the picture. Beyond the evergreens are the pale forms of the hills, which are the most distant section of the landscape. The painting creates a sense of deep space because the landscape is clearly divided into distinct values.

Step 1. The preliminary brush drawing defines the trees as two big, simple shapes. A round softhair brush swiftly glides around the edges of the foliage with a mixture of burnt umber, viridian, and lots of turpentine to make the color flow as smoothly as watercolor. The shapes of the foliage aren't defined *too* precisely. These strokes will soon be covered by thicker color—and that will be the time to render the masses of foliage more exactly.

Step 2. A small bristle brush is used to paint the dark strokes of the trunk and branches with a mixture of viridian, burnt sienna, and white. The strokes are still very loose and casual—the forms will be more precisely painted in the final stages. Then a bristle brush begins to paint the foliage with a mixture of viridian, yellow ochre, and the slightest hint of cadmium red to add a touch of warmth. The strokes already begin to reflect the character of the subject: long, rhythmic strokes for the trunk and branches; short, ragged strokes of thicker color (diluted with less medium) to suggest the texture of the leaves.

Step 3. A bristle brush works its way down to cover the foliage area with short, ragged strokes of viridian, yellow ochre, a hint of cadmium red, and white in the sunlit areas. Then the shadows among the foliage are painted with viridian and burnt sienna, a mixture which also appears in the shadow at the base of the tree. A softhair brush defines the trunk more precisely, using the same mixture as first appeared in Step 2, then adds some shadow strokes with phthalocyanine blue and burnt sienna. A bristle brush begins to suggest the rocks at the bottom of the picture with this same phthalocyanine blue/burnt sienna mixture, adding white for the sunlit planes of the rocks.

Step 4. The sky is painted around the trees with short strokes that overlap one another. The first strokes are cobalt blue and white. These are overlaid with strokes of alizarin crimson and white, and strokes of yellow ochre and white. The action of the brush blends these three tones—but there's no attempt to fuse the strokes into one smooth, continuous tone. Notice how the strokes at the top of the sky are darkest and bluest, growing warmer and paler toward the horizon. Also observe how patches of sky break through the foliage of the big tree.

Step 5. The sky strokes have obscured the brush lines that defined the smaller tree at the left, so now this tree is rebuilt with strokes of the same foliage mixture as was used on the big tree. A bristle brush goes over the sky with short strokes, partially blending the colors that were applied in Step 4, but still allowing each stroke to show. Then the sky mixture—with more blue—is used to paint a darker tone along the horizon. This tone will eventually become the distant hills. The grassy meadow is begun with scrubby, casual strokes of viridian, cadmium yellow, burnt sienna, and white.

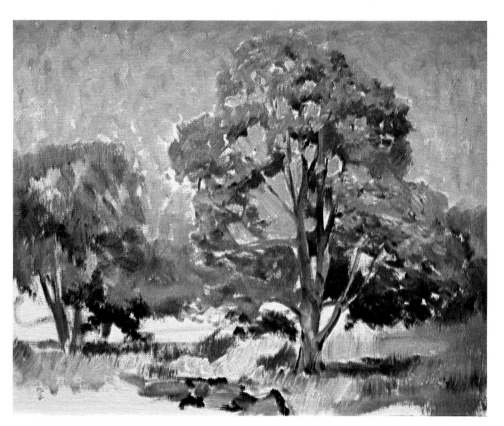

Step 6. The sky is completed with short, diagonal strokes that eliminate the patches of bare canvas. Then the foliage of the big tree is enriched with thick strokes of viridian, cadmium yellow, white, and the slightest touch of burnt sienna—emphasizing the brilliant sunlight. This same mixture brightens the meadow. Between the two trees, broad strokes of sky mixture sharpen the top of the distant hill. All this work has been done with bristle brushes. Now a round, soft-hair brush paints the lights and shadows on the trunks and branches with the original mixtures used in Step 2 and 3, adding more white for the strokes of sunlight. This same brush begins to add dark touches to suggest leaves.

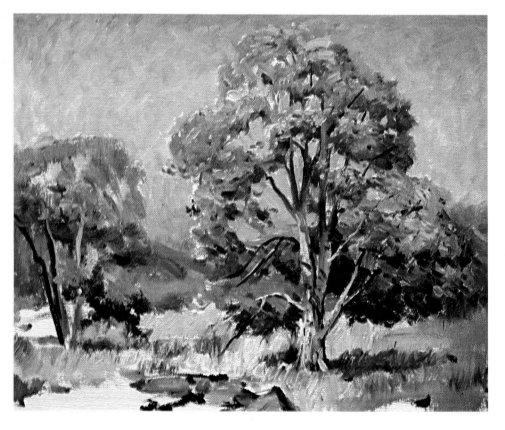

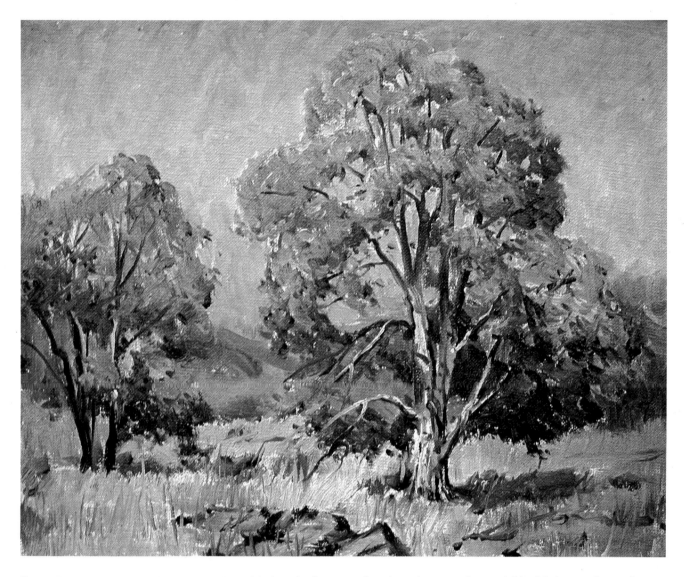

Step 7. It's always important to paint with broad, free strokes until the very end of the picture—when the last few details are added with smaller, more precise strokes. In this final stage, a bristle brush completes the foliage of the smaller tree with broad strokes of viridian and yellow ochre warmed with a speck of burnt sienna and lightened with white. This same tone covers the rest of the meadow. Then the tip of a round, softhair brush goes to work on those last details that give the painting a sense of completeness. The dark trunks of the smaller tree are flowing, rhythmic strokes of phthalocyanine blue and burnt sienna diluted with painting medium to fluid consistency that's just right for linear brushwork. The same brush adds more dark strokes to the trunk and branches of the bigger tree. Then the brush is rinsed out in turpentine, quickly dried on a sheet of newspaper, and dipped into a mixture of burnt umber, yellow, and white to strengthen the lighted patches on the bark. The point of the brush adds a few more dark touches among the trees to suggest individual leaves—but not too many. The round brush sharpens the shapes of the rocks with the shadow mixture that was used on the trunks. Then the tip of the brush scribbles vertical and diagonal strokes over the meadow to suggest grasses and weeds—pale strokes of white faintly tinted with cadmium yellow, plus darker strokes of viridian, burnt sienna, and yellow ochre. The finished painting contains just enough of these details to seem "real," but not enough detail to become distracting. The painting is still dominated by bold, free, broad brushwork.

Step 1. An evergreen forest can be full of distracting detail, so it's essential to keep your eye on the big, simple shapes. Here, the preliminary brush drawing does nothing more than define the trunks of the most important trees in the foreground, the pointed shapes of the forest against the sky, the small tree at the left, the lines of the shore, and a single round tree on the distant shoreline. A round, softhair brush draws these lines with burnt umber, ultramarine blue, and turpentine.

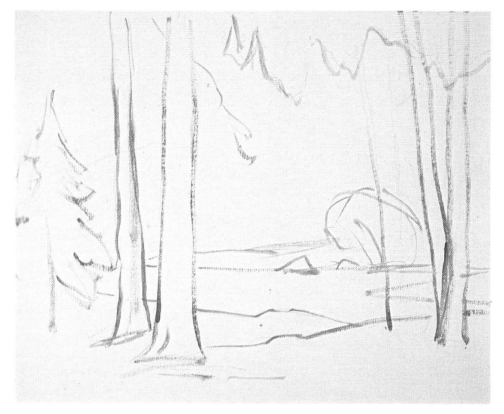

Step 2. Once the composition seems right, the same brush reinforces the original lines with darker strokes of burnt umber and ultramarine blue, but with less turpentine than was used in Step 1. Then the shapes of the big trunks are thickened with this mixture, since they'll become very important design elements—forming the "frame" through which you see the distant landscape.

Step 3. To place the foreground close to the viewer, this area is covered with a rich, dark tone of cadmium yellow, burnt sienna, and ultramarine blue. Strokes of this mixture are carried upward over the small evergreen at the left—with more ultramarine blue added for the darks. Then the tone of the trees on the distant shore is begun with a soft, smoky mixture of yellow ochre, ivory black, and white. All the work is done with bristle brushes, and the color is diluted with painting medium to a smooth, fluid consistency.

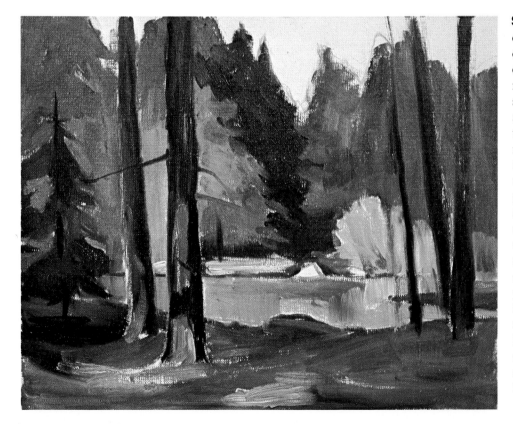

Step 4. The distant forest is covered with broad strokes of creamy color diluted with enough painting medium to make the color flow smoothly. The brightest trees are cadmium yellow and a touch of ivory black; this mixture is carried downward into the water, and a few strokes are added to the foreground to suggest a patch of sunlight. The dark tree at the center is phthalocyanine blue and yellow ochre. The more muted trees are phthalocyanine blue, burnt umber, yellow ochre, and white. Strokes of the foreground mixture are carried upward into the treetrunks on the left; some cadmium yellow is added to suggest sunlight on the bark.

Step 5. The sky is covered with liquid strokes of cobalt blue, alizarin crimson, yellow ochre, and white—defining the edges of the distant trees more sharply. Some of this sky color is brushed into the wet undertone of the distant trees to the right, which grow softer and cooler. The dark trunks in the foreground are more sharply defined by a round brush carrying a dark mixture of phthalocyanine blue and burnt sienna. The brush adds more darks to the small evergreen at the left and begins to add shadow lines to the ground. But something is wrong: the colors of the distant trees are too strong. They seem to be pushing their way into the foreground and need to be pushed back by a radical change in the color scheme.

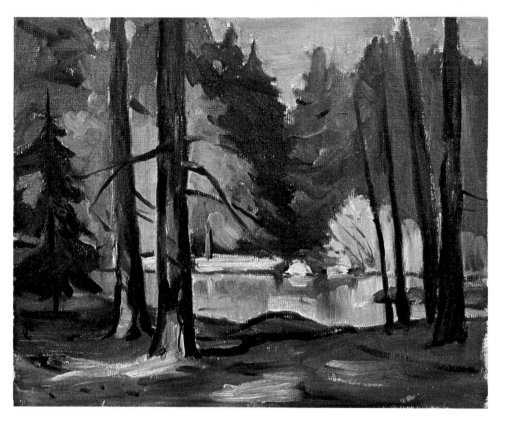

Step 6. The distant trees are scraped lightly with the palette knife. Then soft, warm tones of burnt sienna, ultramarine blue, yellow ochre, and white are brushed over and into the wet tone to create a new, more unified color that stays further back in the picture. Behind the two big trunks at the left, some of the original yellow tone still shines through. The new color is carried down into the water, and some darker strokes of this mixture are added to the foreground. The bark and branches of the foreground trees are painted with dark strokes of phythalocyanine blue and burnt sienna. On the far shore, only one bright yellow tree remains.

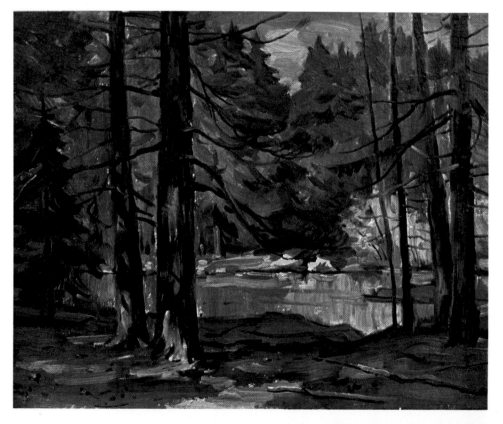

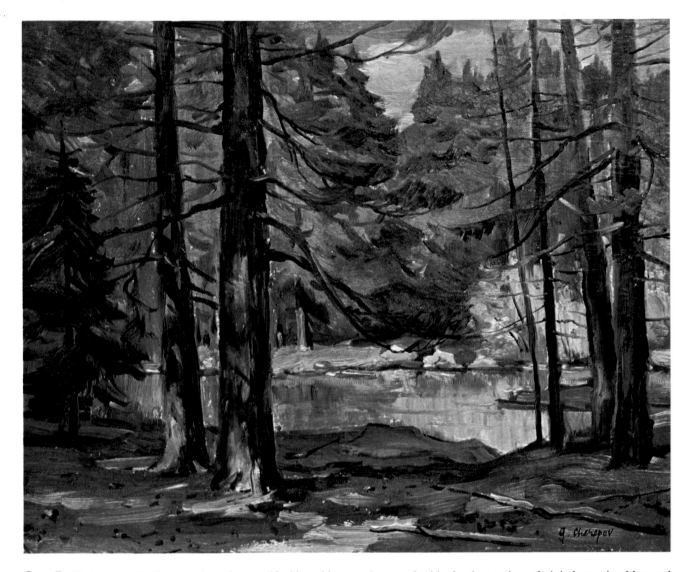

Step 7. The trees on the far shore have been unified by adding fresh color, but now they must be pushed further into the distance. Cool, delicate tones of cobalt blue, burnt sienna, yellow ochre, and white are blended into the wet color to make the distant trees look even more remote and subdued. Behind the treetrunks at the left, the yellow foliage is heightened with a bit more cadmium yellow, burnt umber and white; this mixture is repeated on the shoreline and carried down to the still water, which reflects the foliage above. In the foreground, thick strokes of this mixture, with an occasional dash of cadmium red, suggest patches of bright sunlight breaking through the trees. The tops of the nearby treetrunks are softened with strokes of the same cool mixture that appears on the distant trees in the upper right; this makes the tops of the trunks seem more shadowy and more remote. The dark edges of the foreground trees are sharpened with slender strokes of phthalocyanine blue and burnt sienna applied with the tip of a round softhair brush, which also adds more branches and twigs at this final stage. The patches of sunlight on the trunks are heightened with a few strokes of the cadmium yellow, burnt umber, and white mixture that appears on the ground. A small bristle brush adds a pale, warm cloud to the sky—mostly white, with a touch of cobalt blue and alizarin crimson—and then picks up the blue sky mixture to poke some ''sky holes'' through the foliage. The round softhair brush adds a few dark and light flecks to the ground, suggesting the usual debris of a forest—perhaps some fallen pine cones. The finished painting is an excellent example of the adaptability of oil paint, which remains wet and pliable longer than any other medium—permitting you to make major color changes by blending fresh color into the wet surface.

Step 1. As usual, the preliminary brush drawing is executed with a round softhair brush carrying a very fluid mixture of tube color diluted with lots of turpentine. Because the colors of this landscape will be generally cool, the brush drawing is done in ultramarine blue. The drawing is very simple: just the horizon line, the banks of the stream, the shapes of the foliage, and a few strokes for the trunks of the trees. The sky is brushed in with broad, rough strokes of cobalt blue, alizarin crimson, yellow ochre, and white—with more blue at the top and more yellow below. This sky tone is reflected in the stream.

Step 2. The trees at the horizon are so far away that they contain practically no detail, so they're painted as a broad mass of flat color. They're painted with the same mixture as the sky, but with more blue and less white. The colors aren't mixed too thoroughly; here and there you can see some yellow or pink shining through the blue. This makes the tone of the trees more lively and interesting.

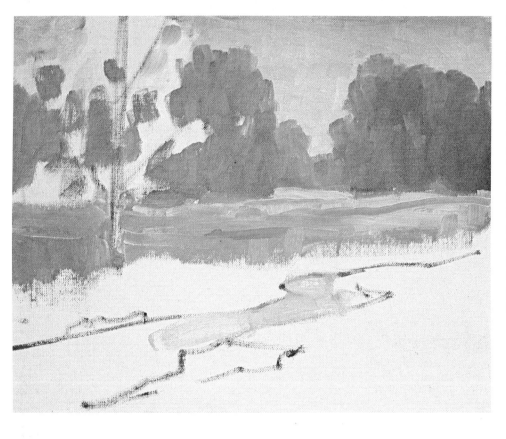

Step 3. The sky and the most distant portion of the landscape are covered with color. Now it's time to begin work on the middleground. The meadow beyond the stream is begun with various mixtures of cobalt blue, yellow ochre, cadmium yellow, and white. The bright patch to the left of center contains more cadmium yellow. Even at this early stage, the brushstrokes express the form. The tall trees in the distance are painted with vertical strokes, while the flat meadow is painted mainly with horizontal strokes.

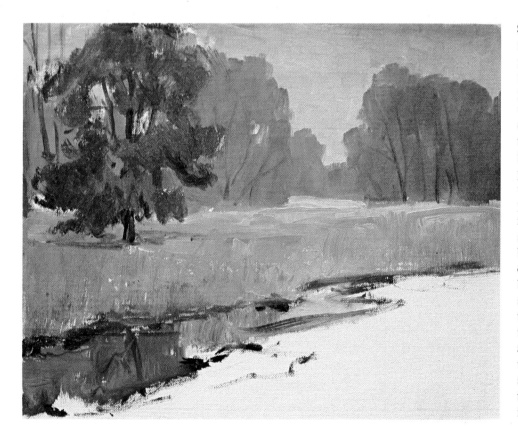

Step 4. The meadow at the far edge of the stream is painted with a brighter mixture of viridian, cadmium yellow, burnt sienna, and white. Now the strokes become vertical to suggest the tall grasses and weeds. The foliage of the dark tree is painted with rough strokes of viridian, burnt sienna, and yellow ochre—repeated in the reflection of the tree in the stream. The trunk and branches are painted with a dark mixture of viridian and burnt sienna. The cooler, softer color of the distant trees is also added to the center of the stream. Some trunks are added to the distant trees with a paler version of the same color used to paint the trunk and branches of the tree in the middleground.

Step 5. Work begins on the foreground. Here's where the color will be brightest and thickest, making the meadow on the *near* side of the stream seem very close to the viewer. Thus, the foreground is executed with a painting knife carrying a thick mixture of viridian, cadmium yellow, burnt sienna, and just a little white. No painting medium is added, so the paint is really thick and pasty. The colors aren't mixed too thoroughly, allowing patches of yellow and brown to show through the green.

Step 6. When the foreground is completely covered with thick color, a softhair brush comes in to convert that heavy mass of paint to grass, weeds, and wildflowers. The job can be done with the tip of a round softhair brush or an old bristle brush with worn, ragged hairs. Picking up various mixtures of the same colors used to paint the meadow in Step 5, the brush paints vertical and diagonal strokes, some dark and some light, to suggest the detail of the meadow. A few quick dabs of cadmium yellow or a mixture of cadmium yellow and cadmium red look like wildflowers.

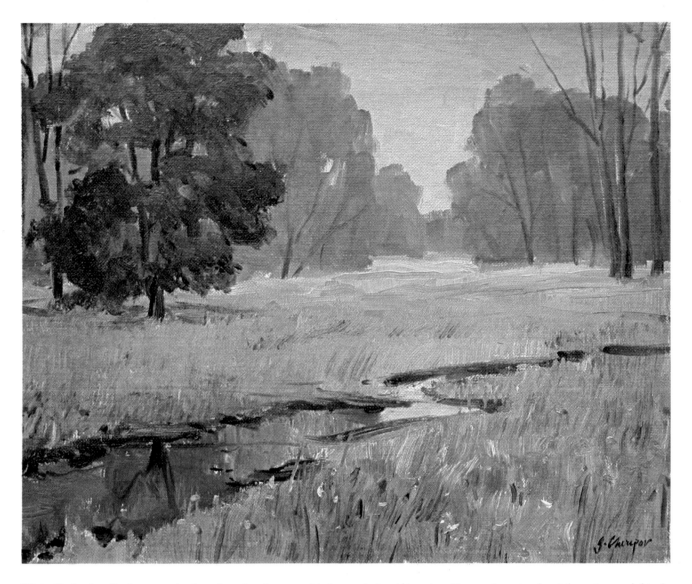

Step 7. In the final stage, the last few details are added with the tip of a round, softhair brush. More weeds and blades of grass are added to the foreground. The dark strokes are burnt sienna and viridian. The lighter strokes are yellow ochre and white. The brush continues to add tiny dots of color to suggest more flowers: bright mixtures of cadmium yellow and white or cadmium yellow and cadmium red; more subdued mixtures of cadmium yellow, burnt umber, and white. Notice that the strokes on the far side of the stream are a much more subtle color—the same mixture used to paint the distant trees in Step 2. The round softhair brush picks up a dark mixture of ultramarine blue and burnt sienna to add some dark touches to the big tree at the left, deepening the shadows within the foliage and suggesting some leaves with a few tiny dots of this shadowy mixture. The bare treetrunks at the extreme left are strengthened with this mixture. A little white is added to this mixture to make a few shadow lines beneath these trees. The composition needs something to balance the big, dark tree at the left, so now the tip of the round brush uses the same dark mixture to add some bare trunks at the extreme right. A few strokes of pure white are added to these trunks to suggest sunlight. Finally, this treetrunk mixture darkens the shadowy banks of the stream and strengthens the reflection of the treetrunk in the lower left area. It's worthwhile to remember the sequence of painting operations in this landscape. Look back over these seven steps, and you'll see that the job is done from top to bottom and from distance to foreground. The sky and the most distant trees are painted first in pale, cool, thin color diluted with lots of painting medium. The middleground—the dark tree and the meadow beyond the stream—is painted next with colors that are darker, brighter, thicker, and more roughly brushed. The immediate foreground comes last. Here the colors are brightest, thickest, and roughest. Details of grass, weeds, and wildflowers are saved for the foreground. The middleground contains only a slight suggestion of detail—you really can't see the leaves on the tree—and the distant trees contain no detail at all.

Step 1. In the summer, hills are often covered with tree foliage. You can't paint every tree on the hill, so it's best to begin a hilly landscape with a few simple brush lines that indicate the overall shapes of the landscape. A round, soft-hair brush traces the lines of the horizon, the hills just below the horizon, the bigger hills in the foreground, the lower edge of the biggest hill where the meadow begins, and a few trees on a slope in the lower right area. The preliminary brush drawing is made with ultramarine blue, a little burnt umber, and turpentine to make the color flow smoothly.

Step 2. Here the painting strategy is totally different from that in the preceding demonstration. The shape of one big hill will dominate the picture. This shape must be the most richly colored area in the painting—and all other parts of the painting must be more subdued. So the biggest, brightest hill is painted first with the rough, vertical strokes of a big bristle brush. The sunlit area is painted with various mixtures of viridian, cadmium yellow, yellow ochre, burnt sienna, and white—never more than four of these colors to a stroke. The darks are ultramarine blue, viridian, and alizarin crimson. The rough, vertical strokes already begin to suggest the texture of the trees on the hillside.

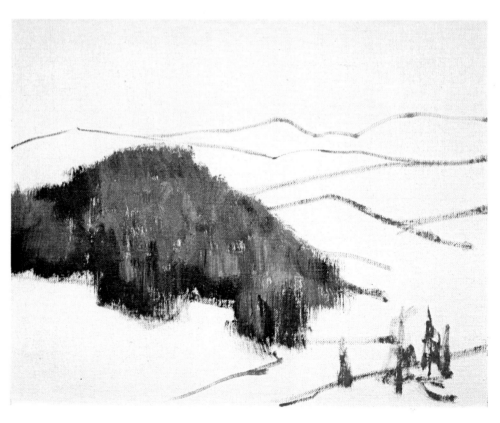

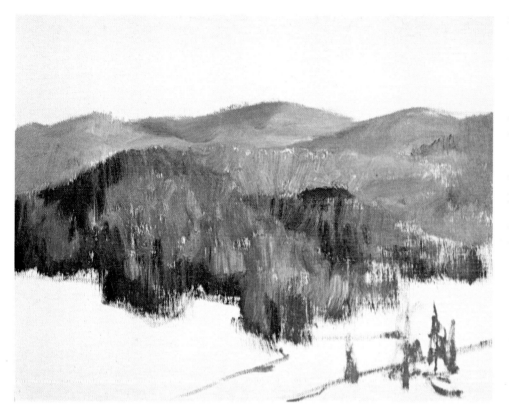

Step 3. The smaller hill to the right of the big hill is painted with vertical strokes of the same colors, but the shadow side (containing more alizarin crimson) isn't quite as dark. There's a much stronger contrast between sunlight and shadow on the big hill that still dominates the painting. Then the distant hills are painted with smoother strokes of slightly more fluid color: ultramarine blue, burnt umber, yellow ochre, and white, with more blue in the shadows. This paler, bluer tone makes the distant hills more remote and provides a subdued background to dramatize the brighter hills in the foreground.

Step 4. The lower sky, just above the horizon, is painted with soft strokes of smooth, fairly fluid color containing a lot of painting medium. This passage is a mixture of cobalt blue, yellow ochre, alizarin crimson, and a lot of white. Observe the smooth brushwork of the distant hills and the lower sky, where the strokes are softly blended together by moving the brush back and forth to obliterate most of the individual strokes. In contrast, each stroke retains its identity on the bright hills in the foreground, making the color more vibrant and the texture more dramatic.

Step 5. More cobalt blue and alizarin crimson are added to the sky mixture to complete the upper sky with a darker, cooler tone. A lot of white is added to this mixture to suggest a single cloud whose lower edge is softly blended into the warm tone beneath. A filbert, the softest of the bristle brushes, smoothes the tones of the distant hills and adds some shadows to the hills at the right with ultramarine blue and burnt sienna. (If you've been painting outdoors, you've probably noticed that clouds cast shadows on the landscape.) Some white is blended into the tops of the distant hills to suggest sunlight. Now a bristle brush begins to work on the meadow in the immediate foreground with paler mixtures of the same colors used on the brightest hill: viridian, cadmium yellow, yellow ochre, burnt sienna, and more white. You can see that some strokes contain more green, more yellow, or more brown. Compare the brushwork in the meadow with the strokes in the hill. The meadow is painted with smooth, horizontal strokes of creamy color that contains as much painting medium as the distant hills. In contrast, the big hill is painted with rough, vertical strokes of thick color. The brushwork reflects the form and texture of the subject. The slope in the lower right area—a small, dark triangle—is painted with the same colors as the meadow, but darker. In the process of painting the meadow, the small trees in the lower right have disappeared, but they'll return in the final stage.

Step 6. So far, everything has been broadly painted. There's been no attempt to suggest the form of a single tree on these densely wooded hills. Now the round softhair brush returns to add the final touches. Just a little more white and yellow ochre are added to the original mixtures that have been used to paint the sunlit hillside. Here and there the small brush adds little dabs of this sunny color to suggest the forms of individual trees. Notice, however, that the original rough brushwork *isn't* completely covered; the round brush adds just enough of these little touches to create the impression of individual trees—and then it stops. The round brush picks up a fluid mixture of ultramarine blue and burnt umber to add the last few dark notes. In the lower right section, the evergreens and their shadows are added with quick touches. A few dark dabs and lines are added to the meadow to suggest individual trees and their shadows, plus some breaks in the meadow. Notice that the lower slopes of the big hill also cast some shadows on the meadow. A few dark touches are added to suggest some darker trees on the wooded hills. Once again, analyze the strategy of the completed painting. The "star" is the big hill with a "supporting actor" to the right. Here's where you see the brightest colors, the thickest paint, the roughest brushwork, and the strongest suggestion of detail. The sky and distant hills are paler, cooler, smoother, and more thinly painted. The meadow in the foreground is smoother and more thinly painted. Nothing competes with the bright, richly textured hills that form the center of interest.

Step 1. The colors of this mountainous landscape are generally cool, so the preliminary brush drawing is made with a mixture of phthalocyanine blue and burnt sienna thinned with turpentine to a liquid consistency. The composition is worth studying. The artist places some shattered trees in the immediate foreground—close to the viewer—to make the mountains seem loftier and more remote. You feel that you're standing in the foreground, looking far into the distance. The top edge of the picture actually cuts off the top of the biggest mountain, making it seem *so* lofty that it won't even fit into the painting.

Step 2. The darkest, most dramatic, and most important shape in the painting is the big mountain, of course. Everything else in the picture will have to be related to that dominant form. So the big mountain is painted first. A large bristle brush blocks in the dark shape with broad strokes of phthalocyanine blue and burnt sienna, with just a slight touch of white and a whisper of yellow ochre. The paint is diluted with medium to a creamy consistency. On the lower slopes, a bit more white is added to suggest a hint of sunlight. Now that the strongest dark note in the painting is established, it's easier to make all the other parts of the painting lighter.

Step 3. The paler slopes at the base of the dark mountain are further developed with he original mixture, but with more white. Now these strokes are sharper and more distinct. The mountains in the upper left are painted with thinner mixtures of the same color combination: phthalocyanine blue, burnt sienna, and a little yellow ochre, plus enough white to lighten these tones. Notice that the warmer mountain contains more burnt sienna, while the cooler shape contains more phthalocyanine blue. The grassy middleground—just beyond the shattered tree stump—is begun with rough strokes of viridian, burnt sienna, yellow ochre, and white. The paler, warmer strokes obviously contain more burnt sienna.

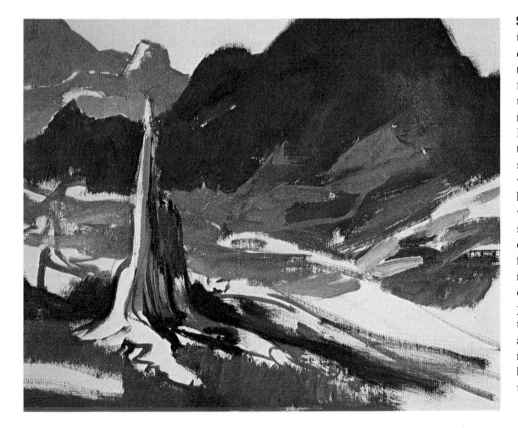

Step 4. The shadow side of the tree stump and the shadowy underside of the fallen treetrunk are painted with fluid strokes of the same mixture that's used to paint the mountains in the distance. Broad tones are laid down by the bristle brush, and then some vertical lines are added with the tip of a round softhair brush to suggest the weathered texture of the stump. The rich, dark green of the grass in the immediate foreground is scrubbed in—mainly with vertical strokes of viridian, cadmium red, and yellow ochre. At this stage, the foreground colors are thin and fluid. Notice that the mountain in the upper left has been made cooler by the addition of more blue.

Step 5. To warm the grass in the lower left area, a bristle brush scrubs in some cadmium red and cadmium yellow. The up-and-down brushstrokes suggest the texture of the grass. Just to the left of the stump, some mountain color is blended into the middleground to suggest a shadowy ravine. More white and burnt sienna are added to the mountain mixture, which is brushed across the sunlit top of the fallen trunk. This same tone appears in the fallen twigs scattered across the grass. In the lower left area, a broken branch is painted in exactly the same way as the fallen trunk. The form and texture of the jagged stump are developed with this same mountain mixture, with more white.

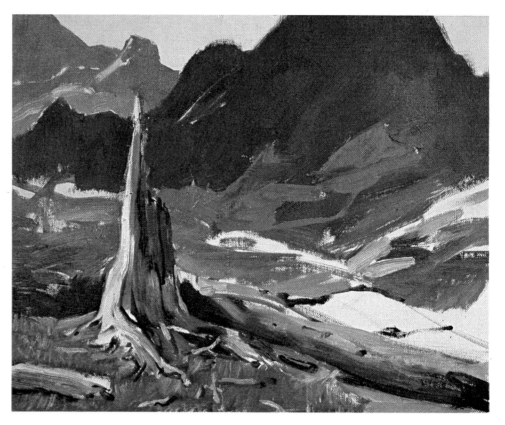

Step 6. To suggest snow at the base of the dark mountain, a bristle brush applies thick strokes of white tinted with the slightest touch of ultramarine blue and burnt umber. A bristle brush completes the sunlit grass with viridian, yellow ochre, a little cadmium red, and white. The top of the fallen trunk—and the log in the lower left area—are enriched with thick strokes of the snow mixture. Then a round, softhair brush picks up a darker version of the mountain mixture to add some evergreens to the middleground, another dark tree at the left, and some dark strokes to the foreground. To suggest sunlight on the new tree and grassy texture in the foreground, the brush adds strokes of the snow mixture.

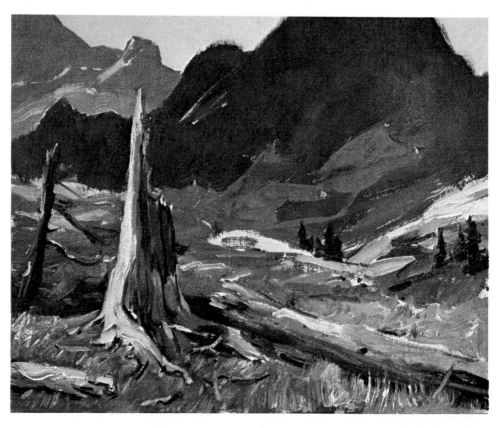

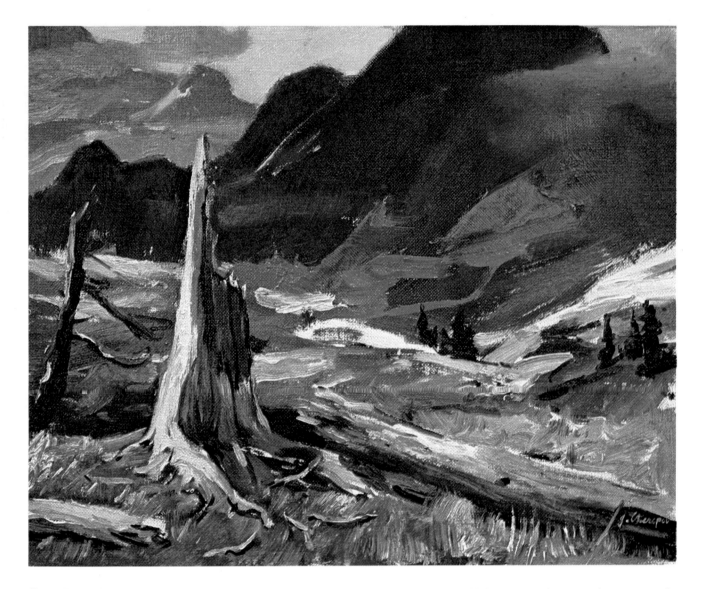

Step 7. Here's where the soft, smooth, flowing stroke of a *flat* softhair brush lends its special magic. Until now, the patches of the sky have been still bare canvas. Now the flat softhair brush covers them with a smooth, fairly fluid mixture of yellow ochre, burnt sienna, and white, cooled with the slightest hint of phthalocyanine blue. Then, with more blue added to this mixture and the paint diluted with plenty of medium, the softhair brush adds a cloud to the sky in the upper left—and carries this cloud over the mountains. The cloud tone blends softly with the underlying mountain color. The softhair brush creates a more dramatic effect at the extreme right. The cloud tone is carried over the edge of the mountain and blended softly into the dark undertone with a back-and-forth motion of the brush; now the mountain seems to disappear into a mysterious mist. A bit of this color is also blended into the dark mountain just behind the shattered stump. Now the distant mountains really seem remote and dramatic. Moving into the middleground, a bristle brush adds some thick strokes of snow mixture—mostly white, with just a touch of ultramarine blue and burnt umber—to the right of the stump. As usual, the final touches of texture and detail are added by the tip of a round softhair brush. Here and there the brush adds a stroke of white—tinted with a little snow mixture—to strengthen the sunlit areas of the broken trees and branches in the foreground. Then the brush picks up a really dark mixture of phthalocyanine blue and burnt sienna to strike in the last few shadow lines beneath the trunks and branches, plus a few more textural details within the shadow side of the broken stump. In the finished painting, notice the effects of aerial perspective. The only sharp details and the strongest contrasts of light and shadow appear in the foreground. The middleground is painted with much simpler, broader strokes. And the distant mountains are painted with broad, flat strokes that emphasize the simplicity of the shapes and contain virtually no detail.

Step 1. This demonstration is painted on a panel rather than on canvas. The panel is a sheet of hardboard covered with acrylic gesso. You can buy gesso panels in some art supply stores, but it's just as easy to make them yourself. Buy a tin or a jar of this thick, white liquid; add enough water to produce a milky consistency; then brush one or more coats onto the hardboard with a nylon house-painter's brush. You can see that this panel is covered with one very thin coat that shows the streaky marks of the brush. The preliminary line drawing is made with cobalt blue, burnt umber, and lots of turpentine.

Step 2. A sunny sky isn't just a smooth, uniform blue like a coat of paint on a wall, but contains lots of subtle color variations. Here's a method for capturing the subtleties of a blue, sunny sky. A bristle brush covers the sky with short, distinct strokes of cobalt blue and white. At the very top, the strokes are darker and closer together. Lower down, the strokes contain more white, and there are bigger spaces between them.

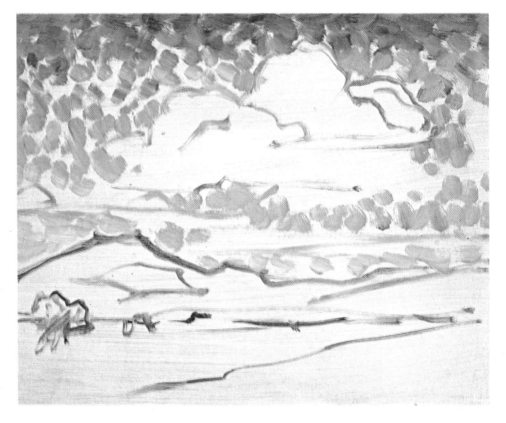

Step 3. Now another bristle brush picks up a mixture of yellow ochre and white. Like the blue tone applied in Step 2, this mixture is added to the sky in short, distinct strokes. These strokes of yellow sometimes overlap blue strokes and sometimes fill the spaces between them. Only a few yellow strokes are added toward the very top; the yellow strokes become denser further down.

Step 4. Alizarin crimson and white are blended on the palette to a pinkish mixture. Like the yellow strokes in Step 3, a few strokes of this pink are scattered across the top of the sky. More pink strokes appear on either side of the big cloud. But the greatest number of pink strokes appear toward the horizon. Now half-close your eyes and look carefully at Step 4. You can see how these three colors are beginning to blend to create a sky that's darkest and bluest at the top, gradually growing paler and warmer toward the horizon. So far, no attempt is made to blend these strokes together. That comes next.

Step 5. With short, slightly diagonal strokes, a clean brush works its way across the sky from left to right and from top to bottom, gently fusing the blue, yellow, and pink strokes. It's possible, of course, to sweep the brush across the sky with long strokes that would blend all the colors smoothly together. But that would destroy all the subtle color variations. The short, diagonal blending strokes preserve all those subtle suggestions of blue, yellow, and pink which make this sky tone so luminous and vibrant. Now the shadowy undersides of the clouds are painted with a mixture of the same three colors (plus white) as in the sky. Notice that some shadow strokes contain more blue, pink, or yellow.

Step 6. The sunlit areas of the clouds are completed with curving strokes of white tinted with slight touches of the shadow mixture. The lights and shadows are blended softly together, but not too smoothly; you can still see the brushstrokes. The pale, distant mountains are painted with exactly the same mixture that's used for the sky—with a little more alizarin crimson in the light tones and more cobalt blue in the shadow. And the darker, nearer mountains are painted with a darker version of this mixture— more cobalt blue in the darks and more yellow ochre in the patch of sunlight at left of center. A few trees are begun with short strokes of cobalt blue and cadmium yellow.

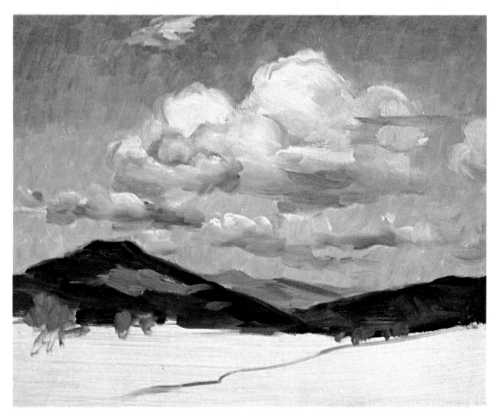

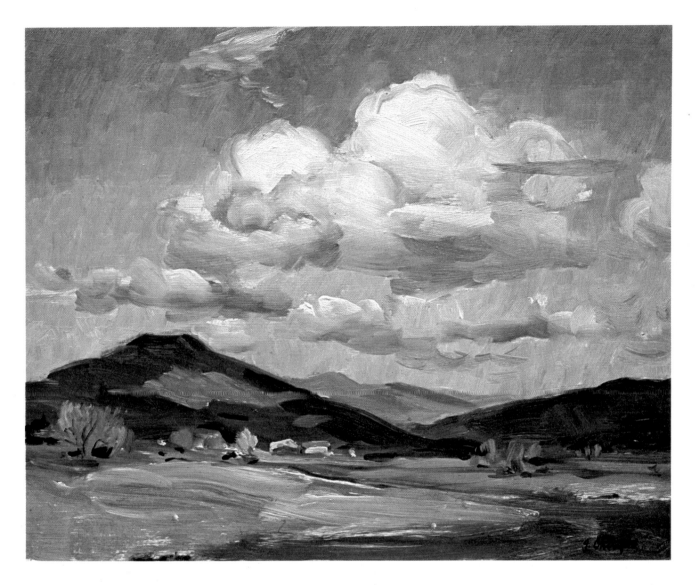

Step 7. The sunny foreground is completed with broad, rapid strokes of viridian, cadmium yellow, burnt sienna, and white. The patch of shadow that travels across the foreground to the right is mainly viridian and burnt sienna. The brilliant sunlight at the center of the foreground is almost pure white, tinted with the grassy mixture. Notice that the foreground strokes aren't smoothly blended: some contain more viridian; others contain more cadmium yellow or burnt sienna. The last few touches are the trees and houses at the lower edges of the mountains. A small bristle brush adds more dabs of cobalt blue, cadmium yellow, and a little burnt sienna to suggest additional trees as well as some white tinted with a little yellow ochre to suggest the sunlit walls of houses and the sunlit tops of the trees. The job is completed with the tip of a round, softhair brush that picks up a mixture of ultramarine blue and burnt sienna to add some shadow lines under the trees, a few dark strokes to the mountains, and a dark line along the road just beneath the houses. The same brush adds a few strokes to suggest a trunk and branches within the tree at the extreme left—this is the mixture used to paint the shadow in the foreground. This brush adds some final warm touches: a line of burnt sienna for the road, some more lines of burnt sienna at the bases of the mountains, and a single stroke of burnt sienna for the top of one house. The brushwork deserves close study. The blue sky consists almost entirely of short, slightly diagonal strokes. In contrast, the clouds are painted with horizontal and arc-like strokes that match the curves of the forms. Most of the strokes in the landscape are long horizontals and diagonals that follow the contours of the terrain. Since this is primarily a sky picture, the clouds are painted with the greatest sense of detail, while the landscape is painted with an absolute minimum of strokes. On the smooth gesso panel, it's *possible* to use a flat softhair brush to blend all the strokes together and create uniform tones that eliminate the marks of the brush—but this would produce a lifeless picture! Instead, each stroke is allowed to show clearly. The smooth panel actually emphasizes the vitality of the brushwork.

Step 1. A sunset usually displays a particularly dramatic pattern of dark and light shapes. The dark landscape and dark clouds are silhouetted against the pale tones of the sky. These dark and light shapes, in turn, are reflected in the water. It's important to define these shapes carefully in the preliminary brush drawing, which outlines the silhouettes of the mountains, the clouds, and the shoreline. The combination of cobalt blue, alizarin crimson, and yellow ochre is particularly effective for sky pictures, as you've already seen. So this mixture is diluted with turpentine for the initial brush drawing.

Step 2. The darkest, most sharply defined shape is painted first. The mountains at the horizon are brushed in with a rich, dark mixture that's mostly cobalt blue, plus a little alizarin crimson, yellow ochre, and white. Just below the shoreline, the reflection of these mountains is added to the water. With this dark note clearly defined, it's easier to determine just how light to make the sky and water. It's also easier to paint the dark clouds, which must be slightly lighter than the dark landscape.

Step 3. Still working with this same color combination—cobalt blue, alizarin crimson, yellow ochre, and white—a bristle brush scrubs in the shapes of the clouds. As you can see, this color combination is amazingly versatile. The cool, dark tones contain all of these colors, but the mixture is dominated by cobalt blue. The warm tone at the center contains less cobalt blue and is dominated by alizarin crimson and yellow ochre. Strokes of these mixtures are carried down into the water, which always reflects the sky. And this same mixture, containing more cobalt blue and less white, defines the murky shape of a hill just below the mountain at the left.

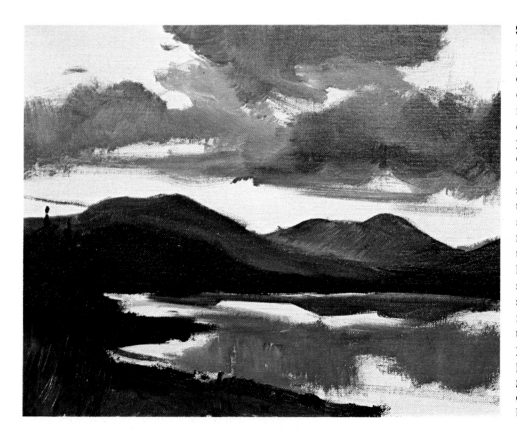

Step 4. Leaving bare canvas for the pale patches of sky and water, a bristle brush continues to define the shapes of the shoreline. The dark mixture of the hill—mainly cobalt blue, with just a little yellow ochre and alizarin crimson—is carried downward at the left to create a spur of land that juts out into the water. The edge of the shoreline in the immediate foreground is completed with this mixture. A round, soft-hair brush adds a few small strokes of this dark tone to suggest the tips of evergreens rising above the dark hill at the extreme left. Then more yellow ochre is added to complete the warmer tone of the grassy beach. The brush handle scratches weeds into the beach at the lower left.

Step 5. Work begins on the bright patch of sky just above the horizon. A bristle brush paints thick, horizontal strokes of white, cadmium yellow, and just a little cadmium red beneath the clouds. Just above the peaks, a little more cadmium red is added. More strokes of this mixture fill the breaks within the lower edges of the clouds. And this same mixture, with just a little more cadmium red, is repeated in the water, which now reflects the forms of the peaks, sky and clouds.

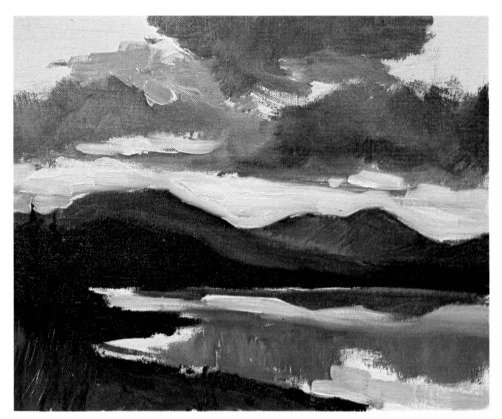

Step 6. Work continues simultaneously on the sky and water, since the same colors must appear in both. The upper sky—above and between the clouds—begins with smooth strokes of cobalt blue and white at the very top. Then, as the brush works downward toward the clouds, yellow ochre and more white are added to this mixture. This process is reversed in the water: cobalt blue and white appear at the lower edge, with more white and yellow ochre added as the brush moves upward. Bright touches of sunlight are added to the lower edge of the topmost cloud with thick strokes of cadmium yellow, cadmium red, and white. And streaks of this mixture are added to the center of the bright sky.

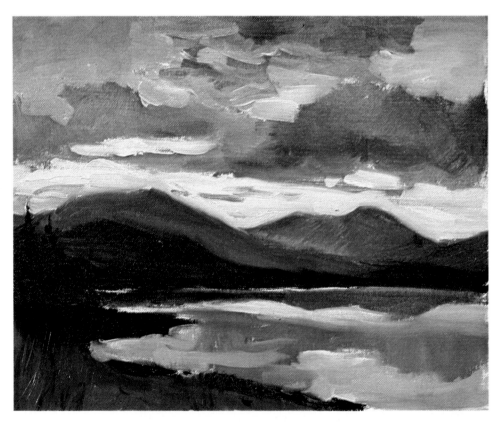

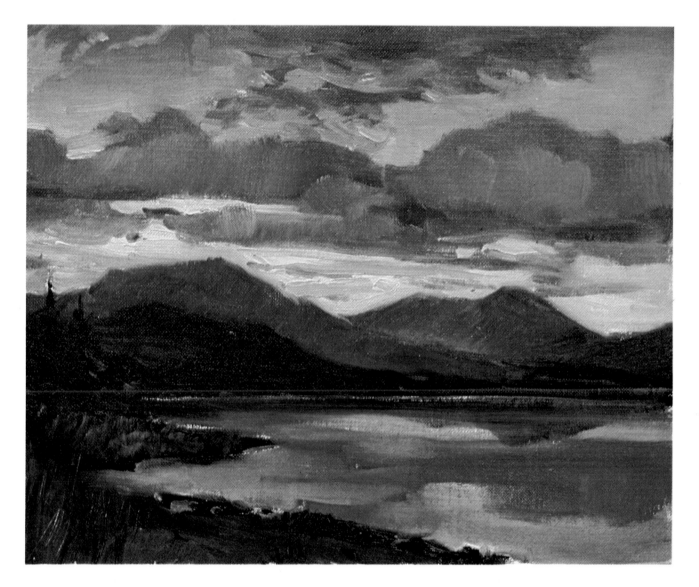

Step 7. At the end of Step 6, the canvas is completely covered with color. The main shapes and colors are established. But now it's time to refine these shapes and colors in the final stage. A large bristle brush moves up and down over the central band of clouds, sharpening their shapes with vertical strokes of the original mixture, sometimes lighter and sometimes darker, to create a distinct sense of light and shadow. A few horizontal strokes of this tone are added to suggest streaky clouds within the sunlit strip above the peaks. And the topmost cloud is darkened with this tone. Just as the dark clouds are redefined, so are the sunlit areas of the sky. A small bristle brush adds thick strokes of cadmium yellow, cadmium red, and white at the break between the peaks, where the sun is brightest. Then a round softhair brush adds curving strokes of this mixture to brighten the lower edges of the two top clouds. Notice how a few wisps of this mixture are added at the upper left to suggest windblown strips of cloud. Having defined the dark clouds more clearly, the bristle brush also solidifies the dark reflections of these clouds in the water. Moving horizontally, the bristle brush blends the tones of the water at the left and in the foreground to soften the shapes so that they won't distract attention from the more dramatic shapes in the sky. The tip of a small bristle brush adds a few scrubs of the cloud mixture beneath the evergreens at the extreme left to suggest the last few rays of the light falling on the grassy shore. No more details are added. The picture consists almost entirely of broad, simple shapes. It's particularly interesting to note that this sunset consists mainly of cool, subdued colors that frame a few areas of brighter color. Sunrises and sunsets are rarely as brilliant as most beginners paint them. At this time of day, most of the landscape is already in shadow, and most of the clouds are dark silhouettes. So the key to painting a successful sunrise or sunset is to surround your bright colors with these somber tones.

Step 1. A moving stream is filled with subtle, complex detail, which is really impossible to draw at this stage. The preliminary brush drawing can do nothing more than define the edges of the shoreline with its rocky shapes; a few rocks in the water; the trunks of the trees along the shore; and their reflections in the water, along with a big, curving ripple in the lower left area. The final picture will be filled with warm sunlight contrasting with the cool tones of the rocks and water; thus the brush drawing is done with a warm mixture of burnt umber, ultramarine blue, and turpentine.

Step 2. The sunlit tones in the distant woods will reappear in the water, so these bright colors are painted first with rough, liquid strokes. The texture of the foliage and the flickering sunlight between the leaves are painted with strokes of cadmium yellow, viridian, and white. Over this goes the more shadowy tone of the woods at the right: ultramarine blue, viridian, and burnt sienna, with a touch of white. At the center of the woods, the quick, casual strokes already begin to look like clusters of leaves.

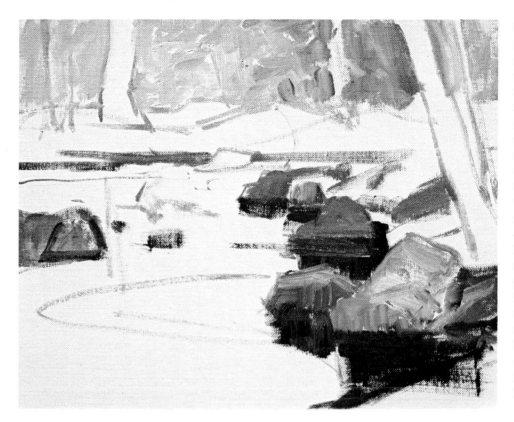

Step 3. The dark, shadowy reflections beneath the rocks are painted with rough strokes of a bristle brush that carries mixtures of burnt umber, viridian, and yellow ochre. The rocks are painted with various combinations of these three colors, plus white. You can see that the warmer rocks contain more burnt umber, while the cooler ones contain more viridian, producing a cool gray. To suggest the blocky character of the rocks and their reflections, they're painted with straight horizontal, vertical, and diagonal strokes that retain the marks of the bristles. Notice that a bit of the yellow-green foliage color is reflected in the face of the biggest rock in the lower right area.

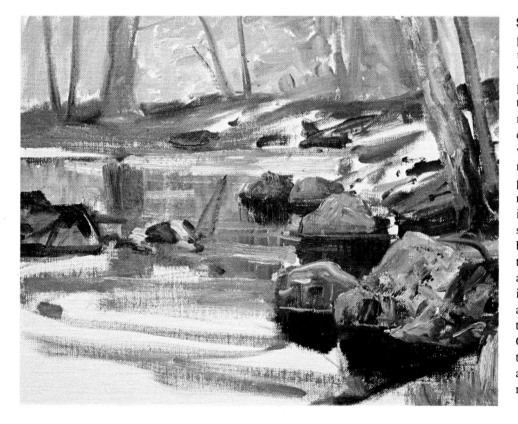

Step 4. The treetrunks are painted with burnt umber, ultramarine blue, and white. This mixture is thickly painted over the rock and the trees at the right. The biggest rock and the thickest trunk are executed with the knife, which leaves a particularly ragged texture. The shore is painted with strokes of this mixture, sometimes containing more burnt umber and sometimes containing more blue. Then a cooler version of this mixture, with more blue and white, is carried down into the water, where vertical and diagonal strokes indicate the reflections of the trees. Over this wet color, horizontal strokes of the bright foliage mixture suggest sunlit reflections.

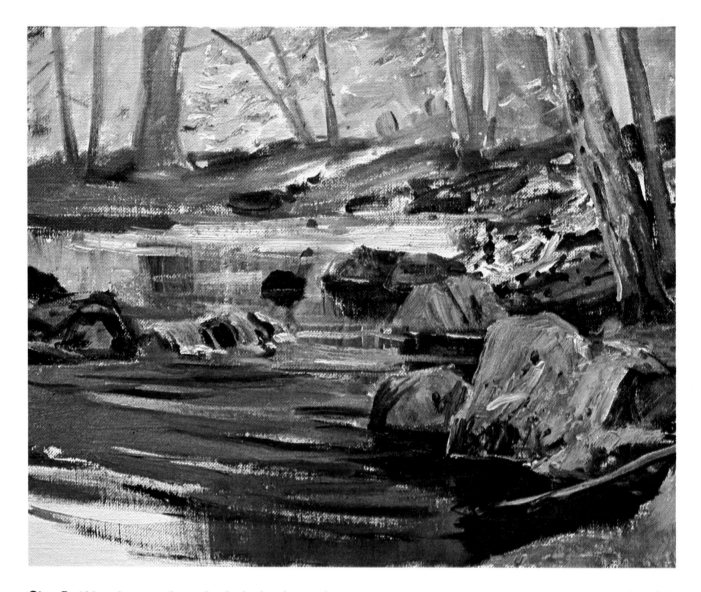

Step 5. Although you can't see the sky in the picture, the bright blue reflection of a sunny sky appears in the water. This is rendered with curving, horizontal strokes of ultramarine blue, viridian, and white, warmed with an occasional touch of burnt umber. As you can see in the foreground, these strokes curve to match the rippling movement of the stream. Horizontal strokes of this color are carried back toward the shore, alternating with strokes of the sunny foliage mixture. The dark reflections beneath the rocks are strengthened with ultramarine blue and burnt umber; shadowy streaks of this tone, lightened with a little white, are carried into the bright water. The sunlit faces of the rocks at the right are textured with thick strokes of ultramarine blue, burnt umber, and white, warmed with a touch of yellow ochre. Scattered strokes of the foliage mixture appear on the rocks to suggest the dappled pattern of sunlight falling through the leaves. The rocks in the stream at the left are darkened with ultramarine blue, burnt umber, and a hint of white. Then a small bristle brush picks up a thick mixture of white warmed with a touch of yellow ochre and carries impasto strokes across the distant stream to suggest the glare of sunlight. A bit of ultramarine blue is added to this mixture, and the same small bristle brush draws curving strokes over the rocks in the middle of the stream to suggest the water spilling over their dark forms. A round softhair brush begins to add more precise touches: some leafy strokes of viridian and cadmium yellow within the sunny forest; and some dark touches of ultramarine blue and burnt umber to suggest pebbles and other shoreline debris above the rocks at the right.

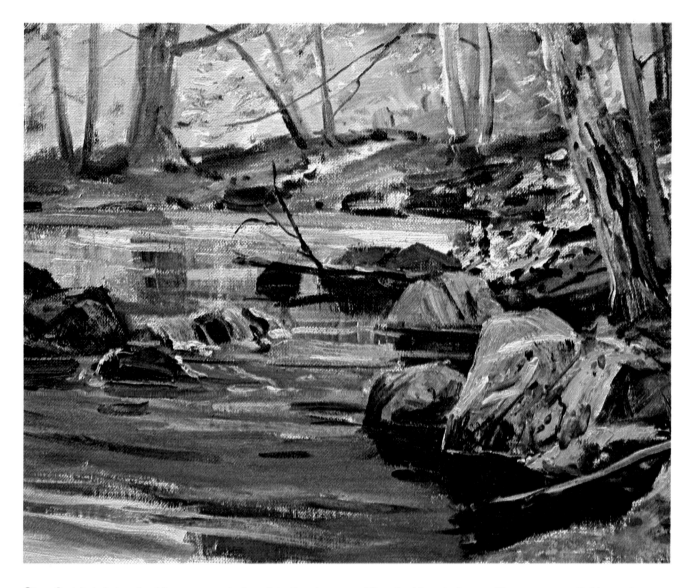

Step 6. A bristle brush adds one more dark rock to the cluster of rocks in the water at the left: a mixture of ultramarine blue, burnt umber, yellow ochre, and white, with more burnt umber in the shadow. Then this brush adds more sunny streaks of cadmium yellow, viridian, and white to the center of the stream; this bright color is softened as it blends with the underlying cool tone. In the foreground, this brush obliterates some of the dark, distracting ripples that you see in Step 5, covering them with the blue mixture—ultramarine blue, viridian, and white, with a touch of burnt umber. Adding thick, pure white to this mixture, the bristle brush makes a flash of light on the water in the lower left. The tip of a round, softhair brush picks up this same cool white to add lines and ripples of foam around and beneath the dark rocks in the water at the left. The same brush adds some streaks of sunlight to the big rock in the lower right with white and a little yellow ochre. Now the round brush picks up a dark mixture of burnt umber and ultramarine blue

diluted with painting medium to a very fluid consistency. The tip of the brush adds a slender, fallen tree to the center of the stream, tracing its branches with delicate, curving lines, and making a horizontal stroke for the reflection of the tree in the water. The tip of the brush adds dark cracks to the big rock in the lower right and to the the thick treetrunk above. Some dark branches are added among the distant woods and two more dark trunks are added in the upper right corner. The tip of the brush adds dark flecks to the distant shore, suggesting pebbles, fallen leaves, and similar details. As always, the brushstrokes and the texture of the paint reinforce the character of the subject. The water is painted mainly with long, smooth strokes of creamy color that emphasize the movement of the stream. The rocks are painted with straight, short, ragged strokes of thick color to emphasize their texture. The distant foliage is painted with quick, random strokes that go in all directions, suggesting the leaves and the flickering light.

Step 1. A "gray" winter day is actually filled with subtle, cool color. So this snow scene begins with a brush drawing in ultramarine blue, burnt sienna, yellow ochre, white, and enough turpentine to make the paint the consistency of watercolor. The drawing does nothing more than define the major shapes: the mass of the trees against the sky; the lines of the bare trunks and a couple of evergreens at the right; the edges of the pond; and the shapes of two rocks in the immediate foreground. There's no point in making these lines too precise, since they'll disappear under the brushwork that follows.

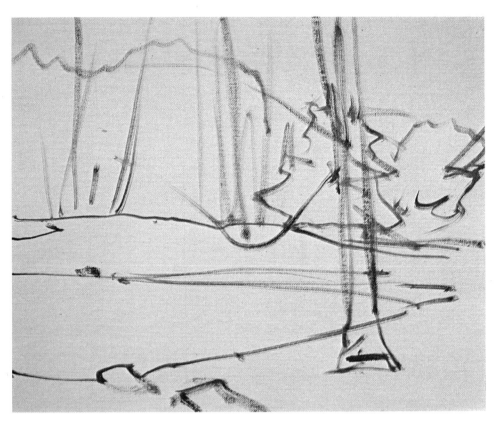

Step 2. Since the ground is completely covered with snow and the pond has turned to ice, the entire lower half of the picture is actually *water*. This means that the ground and the pond will be strongly influenced by the color of the sky. For this reason, the sky is the key to the picture and must be painted first. So the sky is covered with rough strokes of ultramarine blue, burnt sienna, yellow ochre, and white, diluted with medium to a creamy consistency so that the paint spreads smoothly.

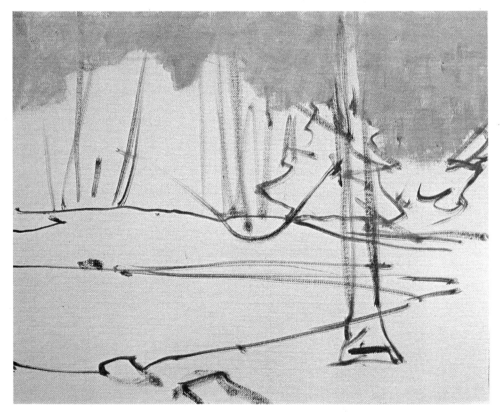

Step 3. The misty woods are essentially the same color as the sky, but darker. So the same big bristle brush paints these woods as a rough mass of color. These woods are again ultramarine blue, burnt sienna, yellow ochre, and white—but containing more blue and less white. The darker, more greenish strokes contain more ultramarine blue and yellow ochre, suggesting that some of the trees are a bit closer to the viewer. The rough brushstrokes retain their identity, suggesting the vague forms of individual trees seen through the mist. Notice the gaps of bare canvas left for the evergreens, which will be painted later.

Step 4. The colors of the trees and sky are carried down into the frozen pond. First the pond is covered with a dark mixture of ultramarine blue, burnt sienna, yellow ochre, and white—approximately the same tone as the woods. This undertone is executed with vertical strokes. Then a paler mixture, matching the sky, is carried across the lake with horizontal strokes that suggest the glint of light on the ice. The darker pond color is drawn across the snow to suggest tree shadows. Then a round, softhair brush goes back into the wet color of the distant woods to draw trunks and branches with the original tree mixture, now darkened with more ultramarine blue and yellow ochre.

Step 5. The two evergreens are painted with short, choppy strokes of viridian, burnt umber, and yellow ochre, with some white added for the snow on the branches. Then a touch of sky color is added to some thick white, straight from the tube, and brushed over the sunlit patches of the snow on the far shore and in the immediate foreground. The thick texture of the paint accentuates the luminosity of the snow. A round softhair brush adds the dark rocks and a few touches of darkness on the distant shore with ultramarine blue and burnt umber. The rock is capped with a single stroke of the snow mixture.

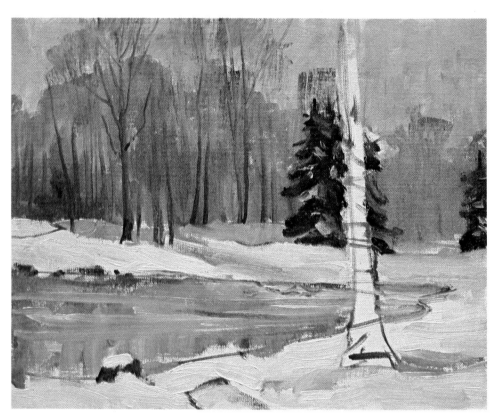

Step 6. With the same dark mixture of burnt umber and ultramarine blue, plus a touch of yellow ochre, a small bristle brush paints the big tree-trunk with rough strokes. A round, softhair brush adds branches and twigs, then darkens some trunks and branches on the far shore with the same mixture—and adds more rocks. The round brush drags thick, irregular strokes of the snow mixture over the dark trunk and branches of the big tree and the dark tree across the pond. Then a small bristle brush darkens the shadows in the lower right area and adds more shadows to the pond behind the tree, using a darker version of the sky mixture. This same color appears in the vertical strokes that suggest tree reflections.

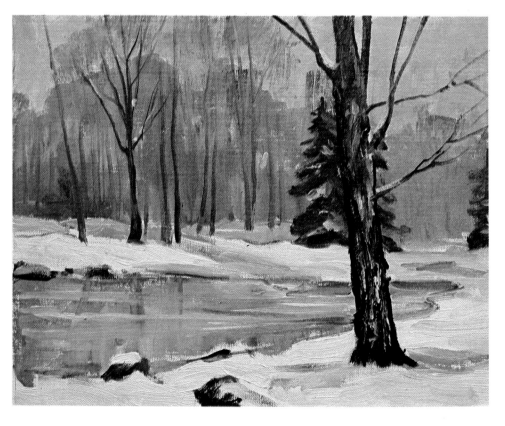

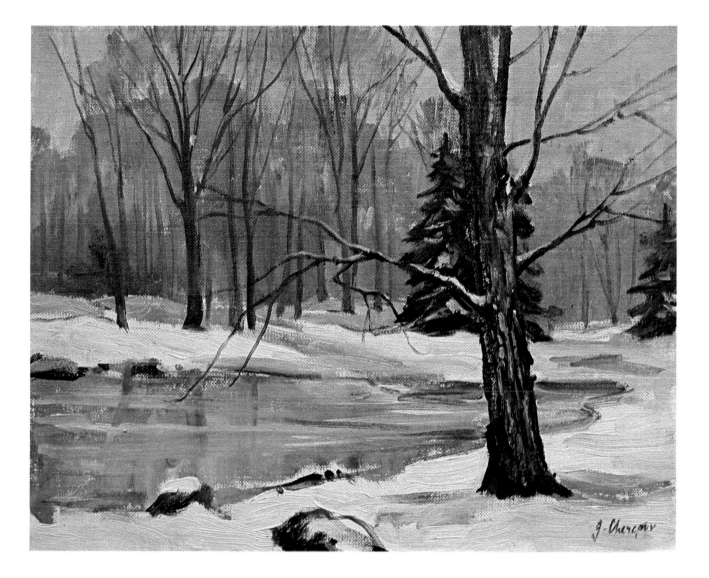

Step 7. The tip of a round, softhair brush completes the distant trees with a dark mixture of ultramarine blue, burnt umber, yellow ochre, and a little white—adding more trunks and branches with rhythmic, delicately curving strokes. A darker version of this same mixture—containing practically no white—is used to add more branches and twigs to the big tree that dominates the foreground. Then the same brush moves carefully along the tops of these dark strokes, adding lines of the snow mixture to suggest a layer of snow resting delicately on the branches. The snow mixture is tinted with a touch of ultramarine blue and burnt umber to produce the light tone of the strokes that travel down the dark trunk, completing the craggy texture of the bark. The round brush adds a few more dark strokes to define the big evergreen more sharply; this is the same mixture

of ultramarine blue and burnt umber, with a little viridian. More strokes of snow are added to the branches of the evergreens. Finally, the tip of the round brush draws a few more horizontal lines of the snow mixture across the frozen lake to reinforce the feeling of light shining on the smooth ice. Remember the color mixtures in this subdued, but rich landscape. These muted tones are full of color because they contain *not one drop of black*. This lovely variety of blue-grays is created entirely with rich colors such as ultramarine blue, burnt sienna, and yellow ochre. Even the blackish tones contain a suggestion of color because they're created with rich hues such as ultramarine blue, burnt umber, and yellow ochre. At the same time, note that the snow is never pure white: snow is water and therefore reflects the tone of the sky.

Step 1. A round softhair brush draws the major shapes of the composition with ultramarine blue, burnt umber, yellow ochre, and white, diluted with turpentine. The shapes of the trees are reflected in the pond, so they're repeated in the water, upside-down. The brush defines the trees rather casually, but carefully traces the outline of the pond—particularly the zigzag contour of the far shore. This zigzag line is important because it leads the eye back into the picture.

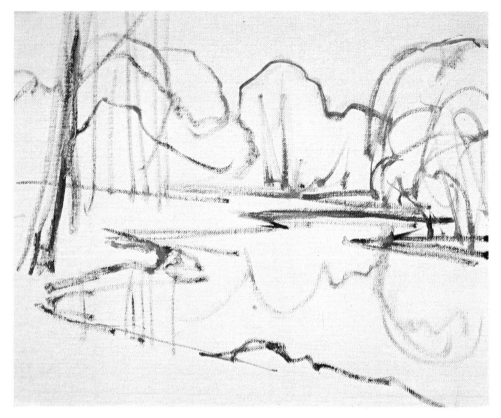

Step 2. This is one of those slightly overcast days when the sunlight shines through and lends a soft, golden glow to the sky and the water. Because the water reflects the color of the sky, these two areas are painted first. A big bristle brush covers the sky with broad strokes of yellow ochre, ultramarine blue, burnt umber, and lots of white. You can see that the sky is slightly darker at the right, where it contains just a bit more ultramarine blue and burnt umber. The water is painted with these same colors—becoming distinctly darker at lower right. Notice that the water is first painted with vertical strokes, followed by a few horizontal strokes to suggest glints of light in the foreground.

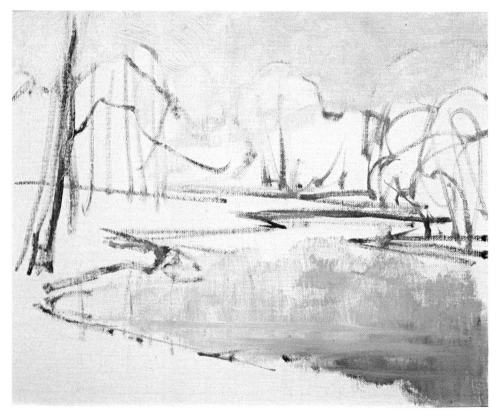

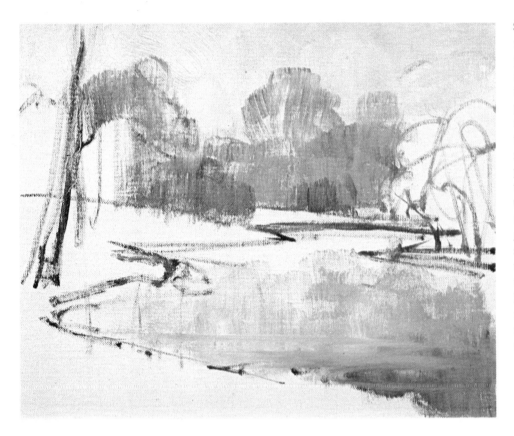

Step 3. The distant trees at the center of the picture are painted with broad, rough strokes that suggest masses of foliage. A bristle brush applies ultramarine blue, alizarin crimson, burnt umber, and white. These colors aren't mixed too smoothly on the palette, so you can see touches of blue, crimson, or umber within the individual strokes. Notice how some gaps are left between the strokes for the sky to shine through the foliage. The warmer mass of trees to the left is begun with strokes of ultramarine blue, burnt umber, yellow ochre, and white.

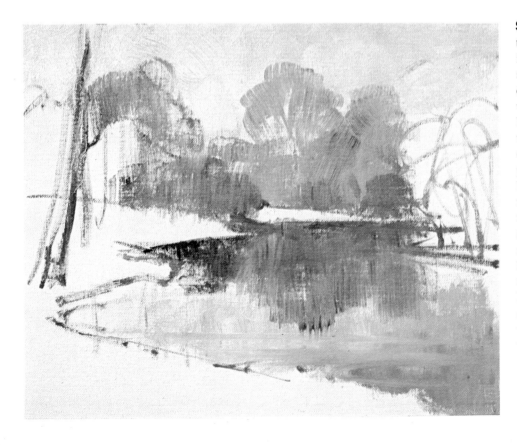

Step 4. The colors of the trees are now carried down into the water with vertical strokes. First the central tree color is darkened and cooled with a bit more ultramarine blue then stroked downward to merge softly with the wet color that already covers the pond. The strokes remain blurred and streaky—very much like reflections. Then the warmer tone of the foliage at left is darkened with a bit more burnt umber and blended into the water with rough, vertical strokes. Notice that a small tree is added to the shore at right with the same colors used for the warm foliage at left.

Step 5. The green willow at the right is first painted as a rough mass of color—a loose mixture of ultramarine blue, cadmium yellow, burnt umber, and white. This is done with a bristle brush, which carries the colors downward into the water. Then the tip of a round soft-hair brush picks up some white, faintly tinted with the green foliage mixture, to strike in some slender strokes of sunlight on the foliage. Finally, the round brush adds dark strokes of ultramarine blue and burnt umber, suggesting a trunk and shadows among the foliage. Notice how most of the brushstrokes curve downward, following the movement of the foliage of the willow.

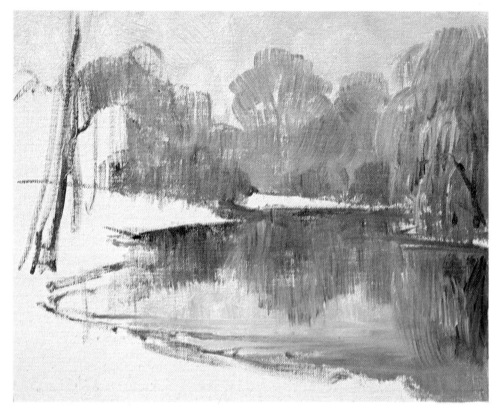

Step 6. At the left, the dark foliage is extended upward and out to the edge of the picture. The ragged brushstrokes do a particularly good job of suggesting the texture of the foliage. The brush doesn't carry too much paint and is dragged lightly over the canvas, allowing the texture of the weave to break up the strokes. The strokes combine several different color mixtures: the cool colors of the most distant trees; the green of the willow; and the warmer tone that first appears in Step 3. The dark reflection in the water is painted with vertical strokes of ultramarine blue, burnt umber, yellow ochre, and white. A round softhair brush picks up this dark mixture to add a few slender tree-trunks among the foliage.

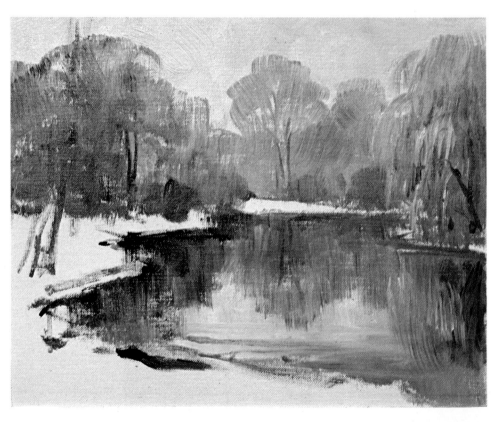

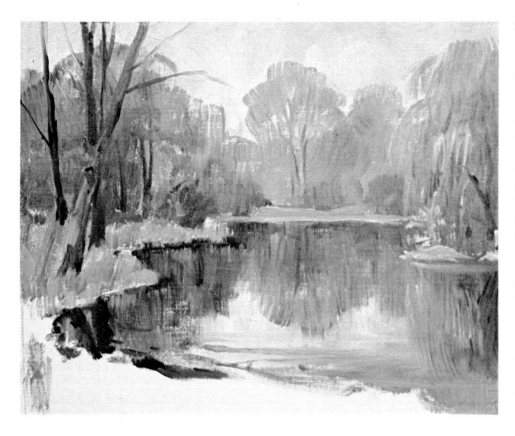

Step 7. Work begins on the shore at the left. The soft, warm tone of the dry grass is scrubbed in with vertical and diagonal strokes of ultramarine blue, burnt umber, yellow ochre, and plenty of white. A round brush paints the treetrunks and branches with this same mixture, darkened with more ultramarine blue, and burnt umber. The dark reflections of these trees are carried down into the water with thick, irregular strokes. The soft tone of the grassy mixture is carried across the distant shoreline and beneath the willow. Here and there along the shoreline a warm touch is added with a quick stroke of cadmium yellow, cadmium red, and white to suggest some bright autumn foliage.

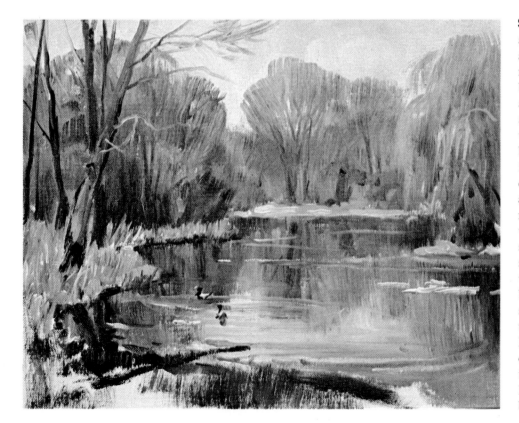

Step 8. A small bristle brush and a round softhair brush alternate, adding shadows, more trunks, and more branches to the distant foliage. These dark reflections are pulled downward into the water with vertical strokes. A bristle brush begins to scrub in the dark tone of the immediate foreground with viridian and burnt sienna. The tip of a round brush picks up some white, tinted with the original sky mixture, to add pale strokes that suggest sunlit weeds on the shore, sunlit branches on the trees, and streaks of light and ripples on the water. Quick dark and light strokes indicate two ducks swimming on the surface of the pond. In the lower left area, a single dark stroke becomes a fallen log.

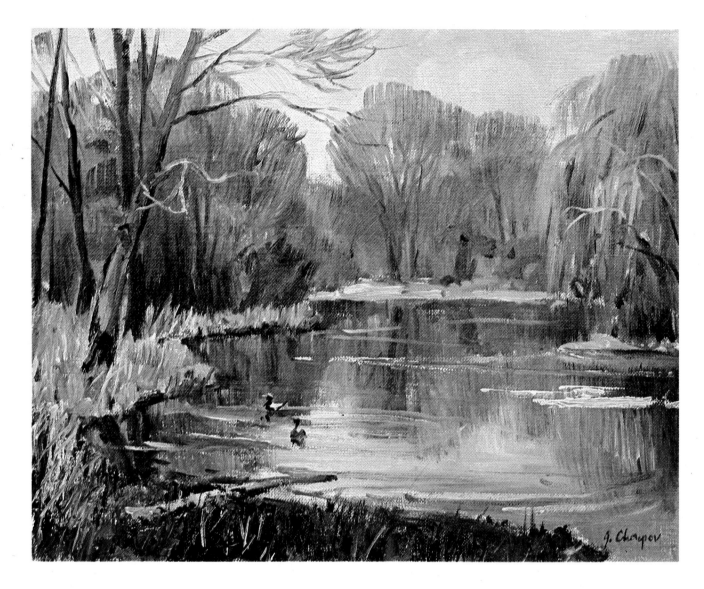

Step 9. The weedy foreground is painted first with rough strokes of yellow ochre, burnt sienna, ultramarine blue, and a touch of white. The paint is thick and rough, applied with a stiff bristle brush. Then the point of a softhair brush goes back into this thick color to pick out individual, sunlit weeds with scribbly strokes of white tinted with yellow ochre. A single stroke of this mixture renders the sunlit top of the fallen log at lower left. Now a small bristle brush and a round softhair brush wander over the surface of the painting, adding touches of darkness and stronger color to heighten the contrasts in the finished painting. Look carefully and you can see where dark notes are added to the foliage and branches with ultramarine blue and burnt sienna. Warm tones are added to the foliage and to the reflections in the water with various mixtures of burnt sienna, yellow ochre, and occasional touches of cadmium yellow or cad-mium red, darkened here and there with ultramarine blue. These subtle changes are particularly evident in the willow at the right, where the shadows are darkened, more dark branches are added, and a hint of warmth is blended into the reflection. Among the foliage of the willow, the round brush adds a few strokes of ultramarine blue softened with a hint of burnt umber and white. The completed painting has stronger darks, sharper contrasts, and greater warmth. The sequence of painting operations is worth remembering. First, the sky is painted—with its reflection in the lake. This is followed by the painting of the foliage—and its reflection in the lake. At this point, the canvas is almost entirely covered with soft color. In the final stages, the painting is completed with stronger darks, warm notes, and the usual touches of texture and detail.

There Are No Perfect Subjects. One of the most famous American landscape painters had a unique system for selecting a subject. He walked for a short time—no more than ten or fifteen minutes—until he found a comfortable rock or tree stump to sit on, plus some trees that would shade his head and his canvas from the sun. (Yes, it's best to keep your painting in the shade; it's easier to see the colors.) Then he turned around three times, sat down, and started to paint whatever he was facing. This method certainly isn't recommended for everyone. But the *lesson* is important. The artist knew that, no matter how far he walked, he'd never find the "perfect" landscape subject, so he might as well settle for an "imperfect" subject, which he could transform into a picture by grouping those scattered trees, leaving out the smaller clouds, and adding some rocks that were *behind* him.

Looking for Potential. Instead of spending hours wandering about trying to discover a ready-made picture, force yourself to stop at the first reasonably promising subject. Like the professional, look for a *potential* picture. Don't worry if the trees are too scattered, the clouds are too small, and the rocks too far away. You're not a photographer, but a *painter*. You can bring all these scattered elements together to create a satisfying picture.

Finding Pictorial Ideas. There are many ways to spot a potential picture. The most obvious way is to look for some big shape that appeals to you, such as a clump of trees, the reflections in a lake, a rock formation, or a mountain peak. You organize the other parts of the landscape around this center of interest, deciding how much foreground, background, and sky to include, then bringing in various "supporting actors" such as smaller trees, rocks, and more distant mountains. Still another approach is to look for some interesting color contrast, such as the hot colors of autumn trees against a background of blue-green evergreens, or the bright colors of a clump of wildflowers against the somber background of a gray rock formation. You might also be intrigued by a contrast of light and shadow, such as a flash of sunlight illuminating the edges of treetrunks in dark woods. Or you might discover an idea for a picture in a contrast of shapes, such as the long, low lines of the plains contrasting with the round, billowing forms of the clouds above.

Orchestrating the Picture. Having found your subject, you still have to decide how to organize the various elements that make a picture. You can't just stick that clump of trees or that rock formation in the middle of the painting, include a little sky and a little background, and then go to work. Just as a famous star needs a supporting cast, the focal point of your picture needs some secondary elements. If the dominant shape in your picture is a big tree, place it a bit off center and balance it against some smaller trees—which will make the big tree look that much bigger. A mountain peak will look more imposing with a meadow and some low hills in the foreground, plus some paler, more distant peaks beyond. If those smaller trees, that meadow and hills, or those distant peaks aren't exactly where you want them, you can *move* them to the right spot in the picture. If they're too big or too small, don't hesitate to change their scale.

Using a Viewfinder. Many landscape painters use a very simple tool to help them decide what to paint. Take a piece of cardboard just a bit smaller than the page you're now reading. In the center of the cardboard, cut a window that's about 5″ x 7″ (125 mm x 175 mm). Hold this viewfinder at a convenient distance from your eye—not too close—and you'll quickly isolate all sorts of pictures within the landscape, far more pictures than you could paint in a day. You can also make a viewfinder simply with the fingers of both hands.

Make It Simple. Knowing what to leave out (or take out) is just as important as deciding what to put into a painting. Nature offers you an infinite amount of detail, and it's tempting to try to load it all into the picture. But you can't include everything. It makes the job of painting much harder and bewilders the viewer. So don't try to paint every treetrunk, branch, twig, and leaf in the forest. Pick out a few trunks and a few branches; try to paint the leaves as large masses of color. Don't try to paint every cloud in the sky, like a vast flock of sheep, but focus on a few large shapes, even if it means merging several small clouds into a big one—and just leaving out a lot of others. Don't try to paint every rock on the beach; pick out a few large rocks for your center of interest, then include some smaller ones to make the big ones look bigger.

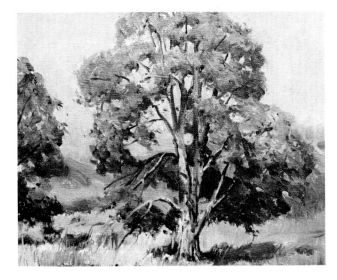

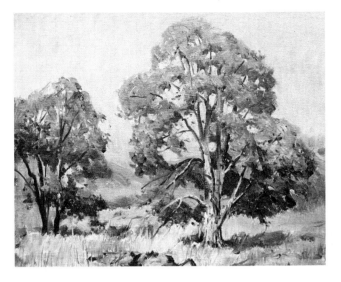

Don't divide your landscape into two equal halves by placing the focal point of the picture in the dead center. Here, the trunk of the big tree runs right down the middle to create a dull, symmetrical composition. To make things worse, the base of the tree sits right on the lower edge of the picture, while the top of the tree pushes right out past the upper edge. So the composition looks terribly crowded.

Do place the focal point of your picture off center. Now the trunk of the big tree divides the picture into unequal parts. The composition is also improved because the big tree at the right is balanced by a smaller tree at the left. And there's more room above and below to give the composition a more spacious feeling.

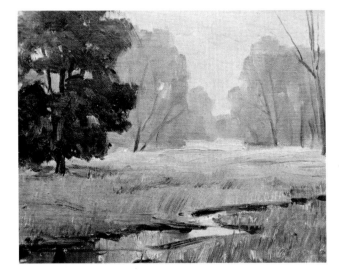

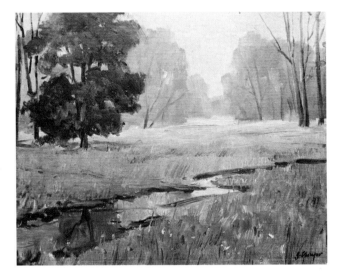

Don't run the horizon straight across the center of the picture. Here, the distant edge of the meadow becomes a line that divides the composition into two equal halves, above and below. This is just as dull as a big treetrunk that splits the composition into two vertical halves.

Do place the horizon above or below the center of the picture. Now the distant edge of the field is slightly above center. This not only divides the canvas into more interesting shapes, but allows more space for the meadow and for the stream that carries the eye back into the picture.

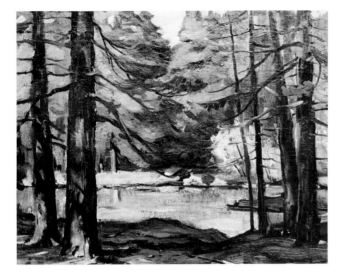

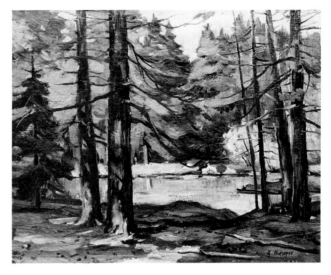

Don't construct a kind of symmetrical "frame" that turns the center of the picture into a box. Here, you can see that the dark trees have been placed neatly around the sunlit rectangle of the lake and the distant foliage. The rectangle is right in the dead center of the picture. This is another one of those dull compositions.

Do place your "frame" off-center. Now the trees have been moved to the right, which means that the sunlit box between the trees is also further to the right. And the sunlit focal point of the picture is now balanced by a dark tree at the left. This is obviously a more interesting composition.

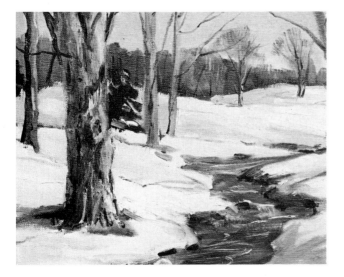

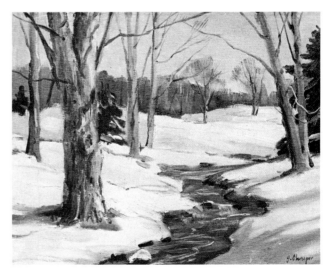

Don't lead the eye out of the picture. The dark stream enters the composition at the bottom and winds around to the right, carrying the eye out past the right edge. You can make this same mistake with a road, a fence, or any compositional element that leads the eye across the landscape.

Do lead the eye into the picture and block any exit. Now the stream has been moved further to the left. It still winds around to the right, but the eye is stopped from leaving the picture—those trees at the right side form a barrier. So the eye travels up the stream and then bounces back into the center of the composition.

Trees in Side Light. When you paint any outdoor subject, it's important to determine where the light is coming from. The direction of the light will determine how much light and how much shadow appear on any subject—such as these trees. In this landscape, the light is coming from the left. Thus, the left sides of the foliage and the trunks are in sunlight, while the rest is in shadow. And shadows are cast on the ground to the right. This kind of lighting creates a strong contrast between light and shadow, giving the trees a dark, dramatic form.

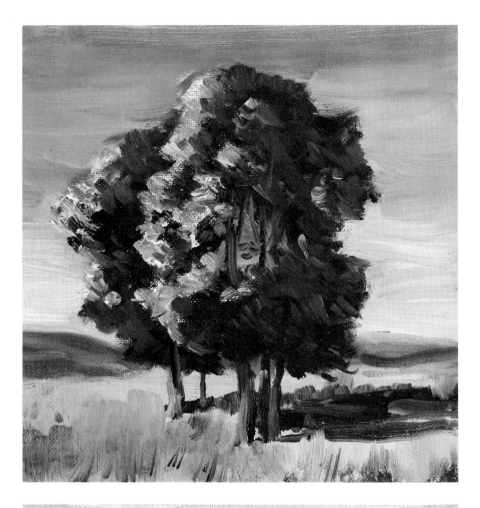

Trees in 3/4 Light. Now the light is coming from the left, slightly *above* and slightly in *front* of the trees. More of the foliage is in light and less is in shadow. The cast shadows on the ground are also shorter because the sun is higher in the sky. These are the same trees you see in the preceding illustration, but the distribution of light and shadow is totally changed.

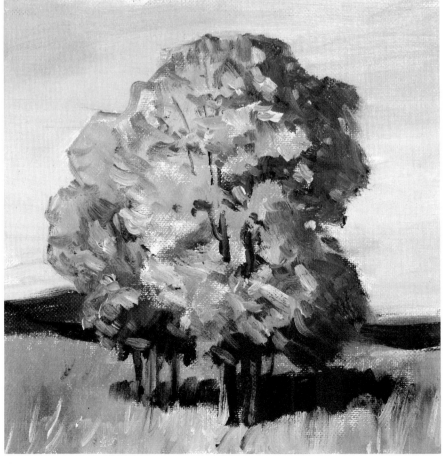

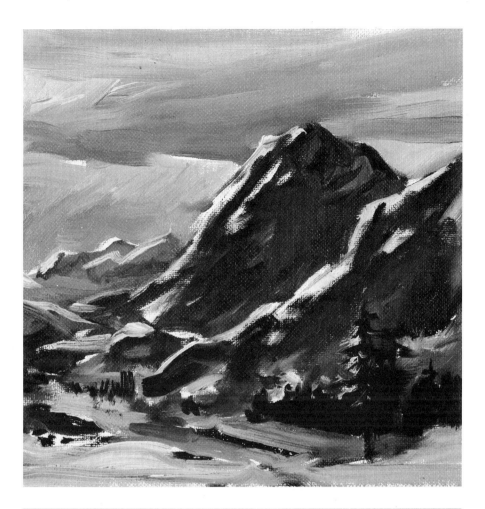

Mountains in Back Light. The sun is low in the sky and behind the mountains. Just a bit of light creeps around the edges of the peaks, but they're almost entirely in darkness. This lighting effect is most common at sunrise and at sunset, when the big shapes of the landscape become dark silhouettes. Landscape painters often choose this type of lighting to create a dramatic mood.

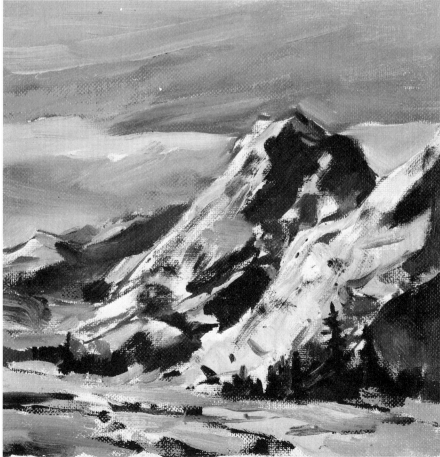

Mountains in 3/4 Light. Now the light comes from slightly above the peaks and from the left. This enlarges the sunlit planes and reduces the shadow planes. The landscape is sunnier, but less dramatic. Try painting the same subject—whether it's trees, peaks, rocks, or whatever—at different times of the day to see how the light alters their forms.

Stream in Perspective. The zigzag shape of this stream, cutting across the meadow, looks random and unpredictable. But the stream clearly moves back into the distance—the shapes obey the "laws" of linear perspective.

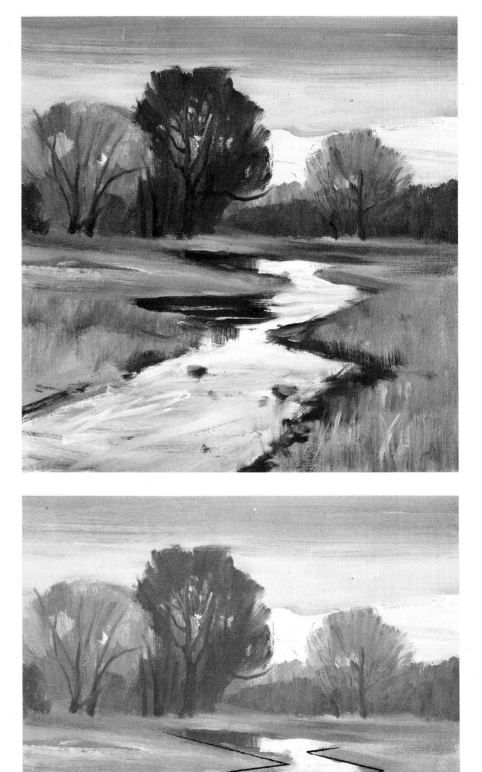

Diagram of Stream. According to the "laws" of linear perspective, parallel lines seem to converge as they approach the horizon. The diagram simplifies the stream into a series of oblong boxes. Notice how the sides of the boxes gradually converge as the oblong shapes approach the distant horizon. This is an effect you commonly see in railroad tracks, walls, and other geometric objects. But it's just as true when you're painting irregular forms such as a stream or a winding road.

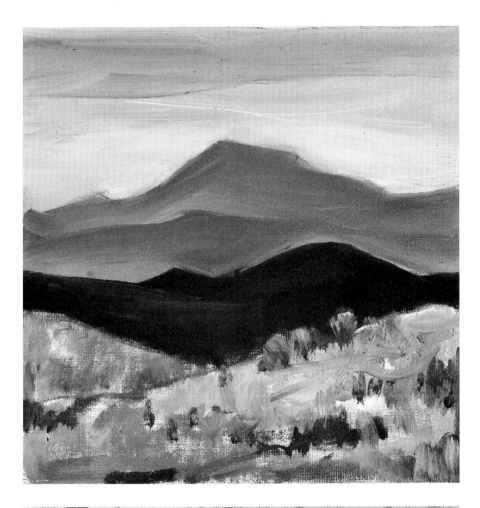

Mountain Range. Aerial perspective is actually much more common—and much more useful—in landscape painting than linear perspective. According to the "laws" of aerial perspective, near objects are brightest, exhibiting the most detail and the sharpest light and dark contrast; distant objects grow paler and less detailed, exhibiting less contrast between light and shadow. These phenomena are obvious in this mountain landscape, where the sunlit fields and the nearby slope are more distinct than the paler forms of the slopes in the distance.

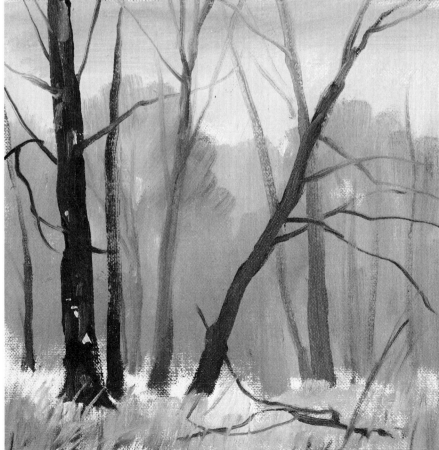

Woods, Near and Far. The effects of aerial perspective are just as obvious in this woodland landscape. In the immediate foreground, you can see the details of grasses, weeds, trunks, branches, and twigs. The more distant trunks grow paler and less distinct. And the mass of trees in the remote distance becomes a pale blur.

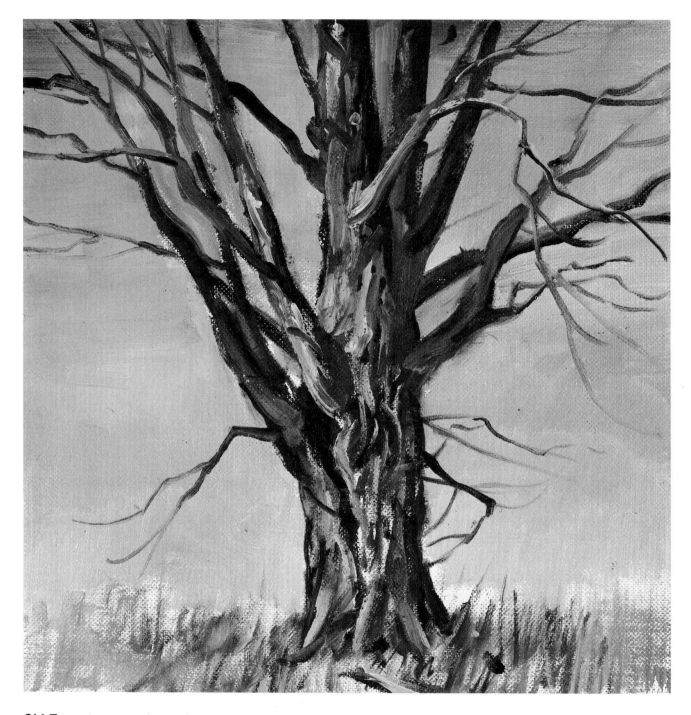

Old Tree. As you study any landscape, try to plan your brushstrokes to reflect the unique character of the subject. This rugged old tree is rendered with wavy, ragged strokes that emphasize the craggy texture of the bark. The lighter strokes are particularly thick, creating the feeling that the paint would be rough if you touched your fingertips to the surface of the canvas. The roughness of the paint actually reflects the roughness of the old tree.

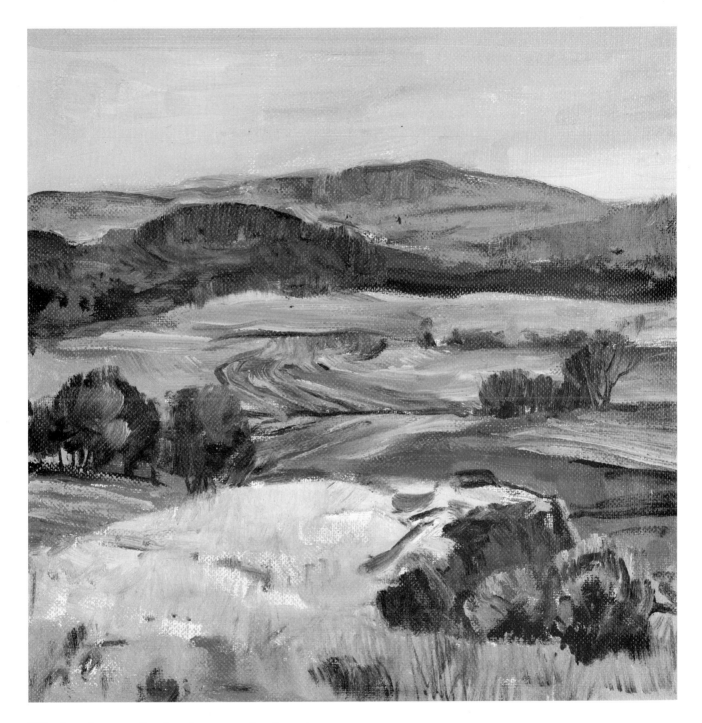

Hilly Landscape. Brushstrokes, properly planned, can also enhance the feeling of three-dimensional form in the landscape. Here, the *direction* of the brushwork actually seems to model the forms. The faces of the distant hills are painted with vertical strokes. The rolling meadow in the middleground is painted with curving strokes. The flat areas of the meadow are painted with horizontal strokes. On the trees, the clusters of foliage are painted with short, curving strokes that seem to "grow" like the foliage itself. In the immediate foreground, the scrubby grass and weeds are rendered with up-and-down scribbling strokes. Thus, the form of each stroke reinforces the form of the subject.

Step 1. The rugged old tree begins with a brush drawing that already reflects the character of the subject. The strokes are made with quick, choppy movements of the hand. The brush doesn't carry too much color, so the texture of the canvas breaks up the strokes and makes the brush mark seem more ragged.

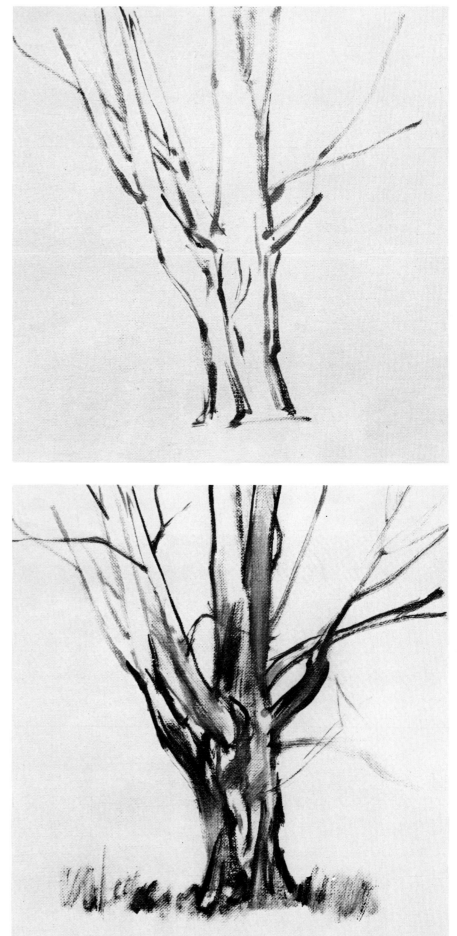

Step 2. The tip of a small filbert reinforces the darks of the trunk and adds shadows with rough, ragged strokes. The brush doesn't move too carefully over the surface of the canvas, but makes erratic, jerky, scrubby movements. Thus, the strokes have a ragged, irregular quality that matches the weathered form and texture of the tree.

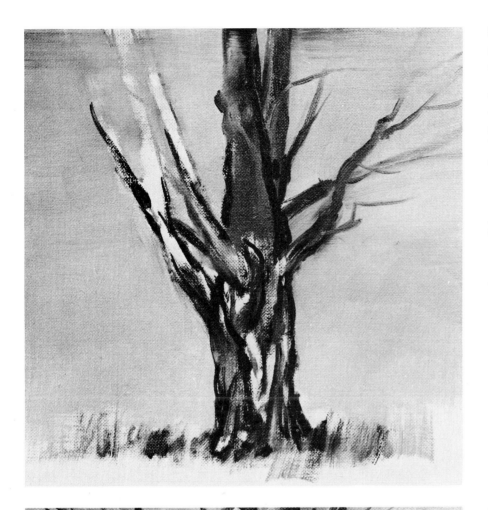

Step 3. A flat softhair brush spreads a smooth, even sky tone around and behind the tree. The smoothness of this tone emphasizes the roughness of the tree by contrast. Then a bristle brush begins to scrub in the dark tones of the trunk, blurring and softening some of the original brushwork applied in Steps 1 and 2. So now the tip of a round softhair brush returns to reinforce some of the dark lines. The brush is pressed down hard, spreading the hairs so that the strokes have a more ragged quality. The round brush also re-establishes some of the dark branches at the right—which were obliterated by the tone of the sky.

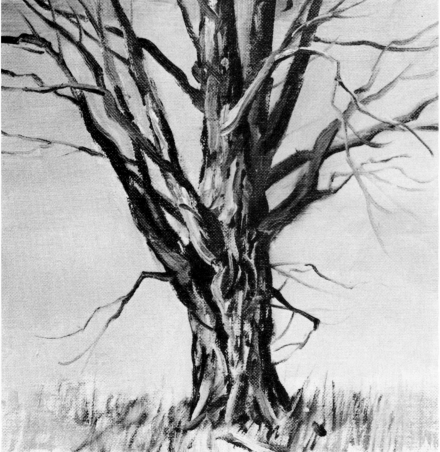

Step 4. The dark trunk, branches, and twigs are completed with quick, choppy strokes of a small filbert and a round softhair brush. Then the filbert and the softhair alternate, applying thick lines of pale color over the darks to emphasize the sunlight falling on the weathered, irregular texture of the bark. These light strokes contain no painting medium. The color is thick, just as it comes from the tube. The strokes actually stand up slightly from the surface of the canvas. The texture of the paint appears to match the texture of the subject.

Step 1. The preliminary brush drawing is made with very fluid color diluted with enough turpentine to make the strokes flow smoothly and rhythmically. The round softhair brush carefully traces all the curving forms of this hilly landscape.

Step 2. The bristle brush now begins to model the forms in the foreground. Vertical strokes move down the shadowy side of the cliff in the lower right. At the left, a triangle of flat land is painted with horizontal strokes. Above this, the dark trees are modeled with short, rounded strokes that begin to match the round masses of the foliage.

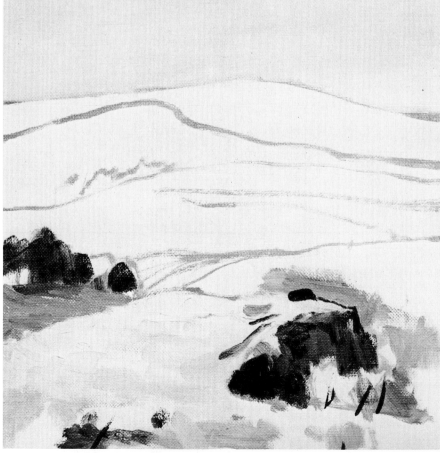

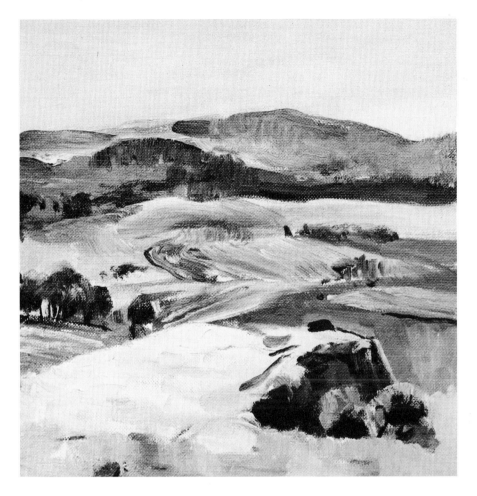

Step 3. The placid sky is covered with smooth, horizontal strokes that become almost invisible. The rounded forms of the distant hills are first painted with curving horizontal strokes. These are followed with short, vertical strokes that suggest the vertical, shadowy faces of the cliffs. The brush moves in rhythmic curves to match the rounded forms of the meadow. The flat portions of the meadow are rendered with straight, horizontal strokes.

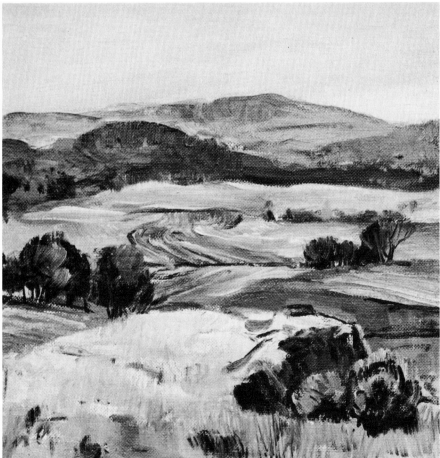

Step 4. To reflect the growing forms of the trees, the dark strokes seem to spring upward from the ground. The pointed brush draws long rhythmic, curving lines across the meadow and short, rhythmic lines for the treetrunks. The foreground is completed with scrubby strokes in which the brush is moved up and down to suggest the texture of the grass and weeds on the nearby hilltop.

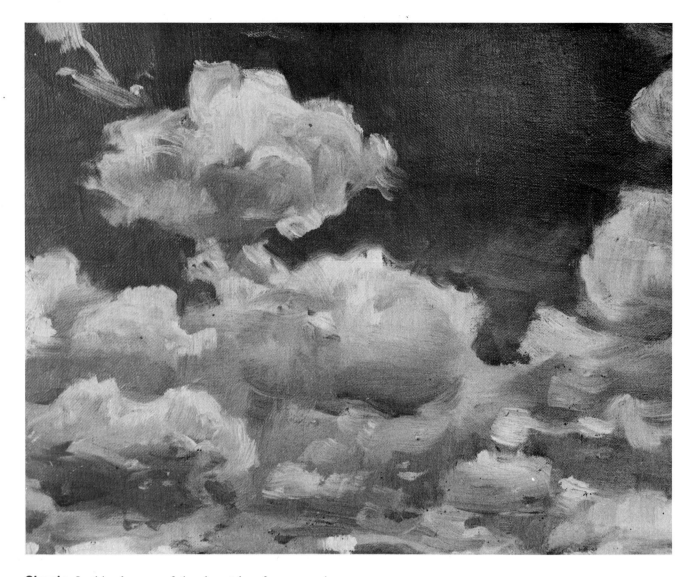

Clouds. In this close-up of the sky—taken from a much larger landscape painting—you can see clearly how the brushstrokes express the texture, the form, and even the movement of the subject. Clouds are never motionless, but are always pushed along by the wind, which gradually tears them apart and reshapes them. The shadowy undersides of these clouds are painted with soft, arc-like, curving strokes that not only express the rounded forms of the clouds, but also make them appear to be moving across the sky. The sunlit tops of the clouds, torn by the wind, are painted with short, curving, slightly nervous strokes that blur the edges of the cloud shapes. The brushwork in the lower right area is particularly interesting. Notice how the small cloud shapes are painted with short irregular strokes that seem to be dragged across the sky by the wind. The entire sky seems to be in motion. You can feel the wind blowing through it.

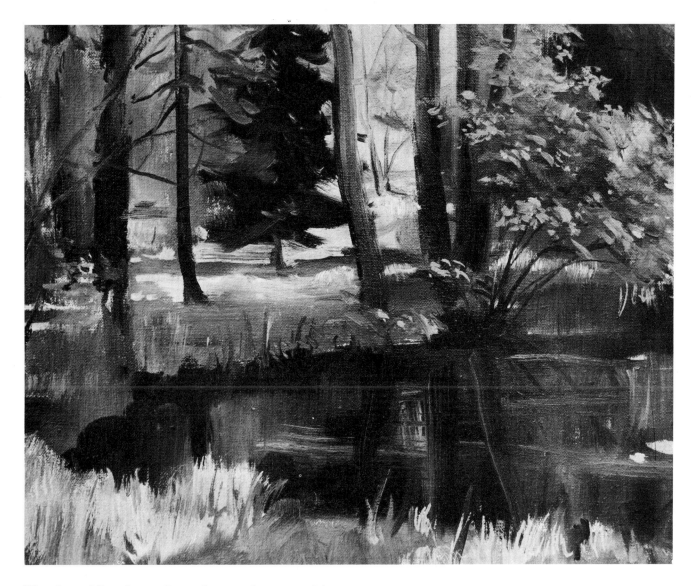

Woods and Pond. The diverse forms and textures of the woods—filled with treetrunks, foliage, grass, weeds, and water—require varied brushwork. The trunks are smooth, long, slightly curving, vertical strokes. To render the dark shape of the evergreen with its jagged masses of foliage, the brush presses down and pulls outward to the side. The flowering tree in the upper right area is painted with quick touches of the very tip of a round brush—the brush is pressed lightly against the canvas and then quickly pulled away. The dark pond is an interesting combination of vertical, horizontal, and diagonal strokes. First, the blurry tones of the reflections are painted with vertical movements of the brush. Then the reflections of the trunks and branches are painted with darker verticals and diagonals. Finally, the streaks of light on the surface of the pond are painted with slender, horizontal strokes. The weedy underbrush surrounding the pond is painted with scrubby, up-and-down strokes. None of this brushwork happens by accident. You've got to get into the habit of planning the stroke before you touch the brush to the canvas.

Elm. Learn to recognize the distinctive silhouette of every tree. The elm's trunk and branches are essentially vertical, gradually fanning out. The foliage forms a curving umbrella.

Apple. The branches of the apple tree are more jagged and unpredictable, reaching out in all directions. The foliage is sparse and scrubby, revealing the branches.

Oak. The branches of the oak grow upward and outward from the thick, sturdy trunk. The dense rounded mass of foliage conceals many of the branches.

Spruce. The spruce is like a series of arrowheads, pointing upward. The outer edges form a zigzag pattern. The dense foliage hides the trunk and branches.